P9-DFU-693

THE
DECORATIVE
PAINTER

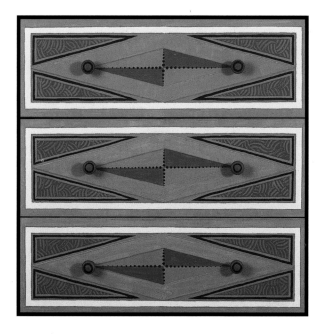

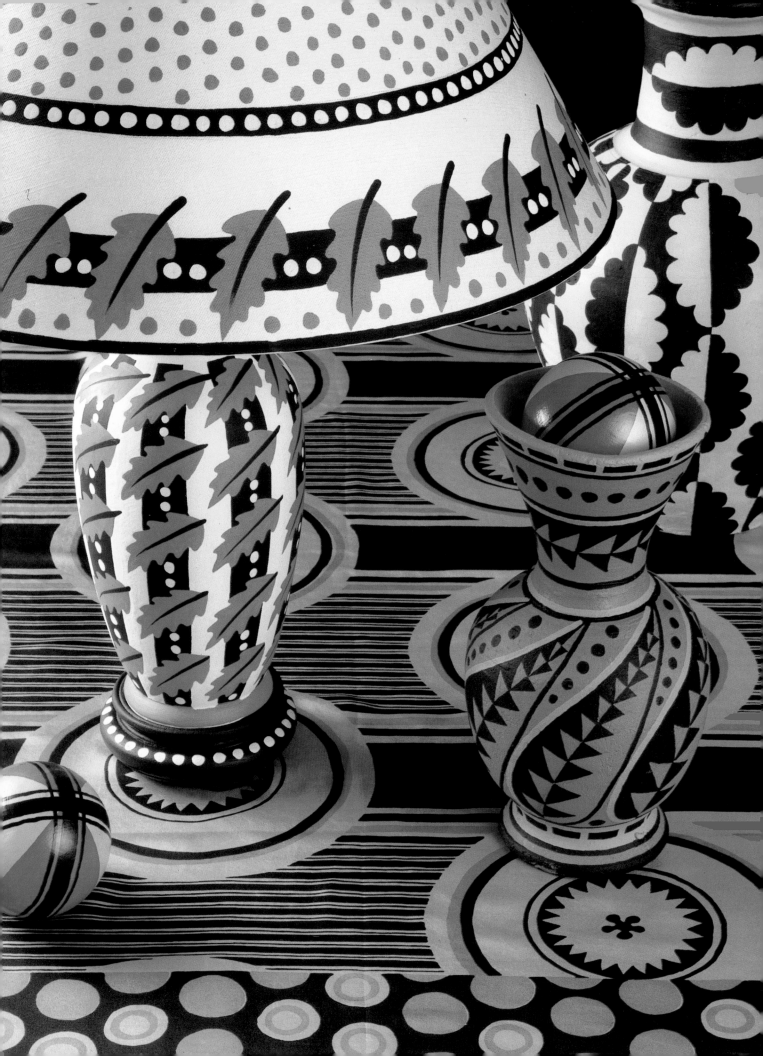

Cressida Bell
THE
DECORATIVE PAINTER

OVER 100 DESIGNS AND IDEAS FOR PAINTED PROJECTS

Special photography by Nadia Mackenzie

A Bulfinch Press Book
Little, Brown and Company
Boston • New York • Toronto • London

To Christine with love and thanks, and to Paul xxx

First published in 1996 by
Conran Octopus Limited

Text and patterns copyright © 1996 by Cressida Bell
Compilation copyright © 1996 by Conran Octopus
Special photography copyright © 1996 by Nadia Mackenzie

British Library Cataloguing-in-Publication Data
A catalogue record for this book is available from the British Library

First North American Edition
ISBN 0-8212-2267-8
Library of Congress Catalog Card Number 95-78099

Bulfinch Press is an imprint and trademark of Little, Brown and Company (Inc.)
Published simultaneously in Canada by Little, Brown and Company (Canada) Limited

PRINTED IN CHINA

CONTENTS

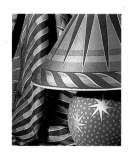

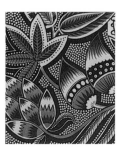

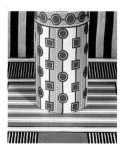

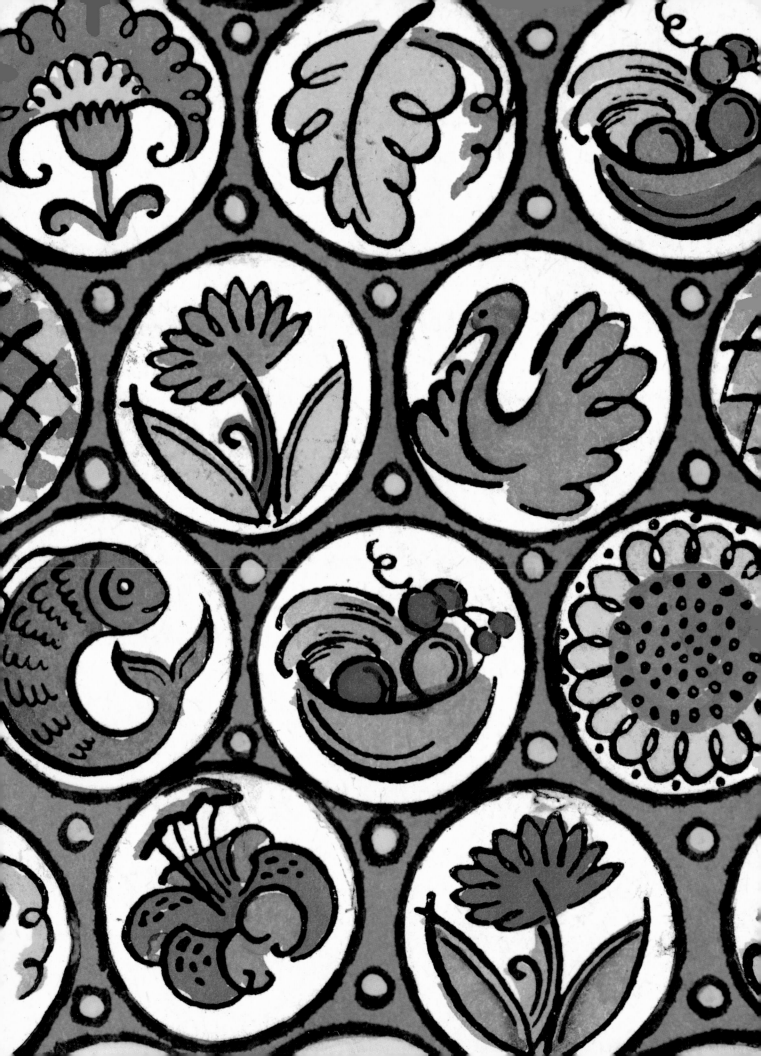

FOREWORD

*This book is intended primarily to encourage and
enable you to decorate all manner of everyday objects. In it
I hope to share my own enthusiasm for all the possibilities
presented by design and decoration, and the great
pleasure to be had in the easy transformation that can be
achieved with only the most basic materials.*

*It should be feasible to start and finish each of
the fifteen projects within the space of a weekend, and no
expensive equipment or difficult techniques are required.
A selection of templates is included for help and
inspiration, and on each page I have included as many
extra design ideas as possible. Above all, I hope you will
enjoy the projects and gain a sense of fulfillment
from completing them.*

Cressida Bell

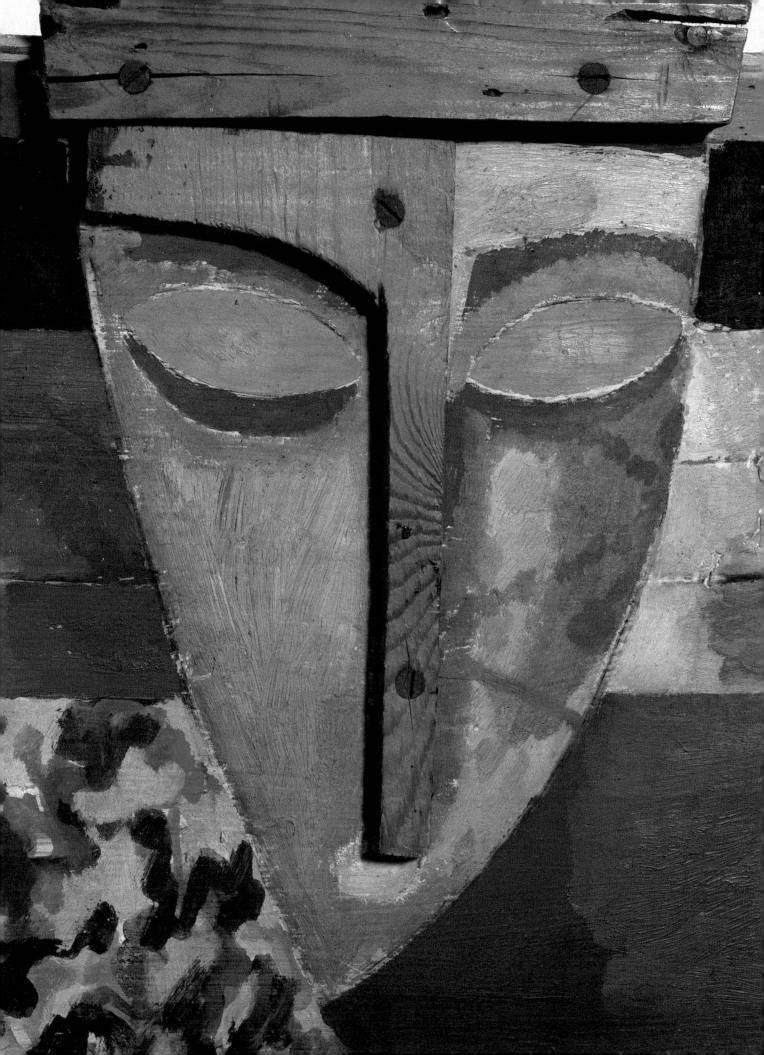

INTRODUCTION

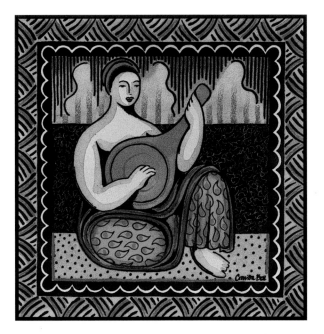

With a background in the decorative art of Bloomsbury, I suppose it is not surprising that I became a designer. I never wished to become a fine artist as I wanted to do something with a more practical application, so I trained to become a textile designer. However beautiful a scarf may be, it still has a definite use, and it is the same impetus that drives me to decorate walls and furniture. You cannot live your life without them so they might as well be as attractive as you can make them. I hope that this book will appeal to the home-maker in you as much as the artist, and show that this sort of decoration is easy and inexpensive.

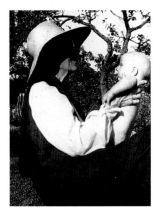

This picture of Vanessa Bell, my grandmother, holding me as a baby, was taken at Charleston, Sussex, UK in 1959 by my mother Olivier. It is one of the few pictures of us together, as she died two years later.

Previous pages:
Left: A detail of the 'Morpheus' bedhead painted circa 1917 by Duncan Grant for Vanessa Bell. This was in my father's room at Charleston where we spent a lot of time as children.
Right: 'Woman and Mandolin' cushion designed in 1991 as a Bloomsbury pastiche. It is based on a bookcase by Duncan Grant which we had at home for years but which is now back in its original place in the library at Charleston.

I AM ALWAYS being asked about my family background and whether it has influenced my work. It is hard to be sure how much you are affected by your upbringing and surroundings, but there is no doubt that I have absorbed or inherited something from my family. Both my parents, Quentin and Olivier Bell, are art historians and as children we were surrounded by adults who were involved in art in some way. My father made sculptures for the garden and pottery for the house, and produced wonderful illustrated books and cards at Christmas. My mother has always been highly practical, turning her hand to anything – putting up a shelf, making drapes, and even embroidering our baby clothes when we were little.

We spent many vacations at Charleston, the Sussex farmhouse which was the home of my grandparents, Clive and Vanessa Bell, and of Duncan Grant. They were members of the Bloomsbury Group, a circle of both literary and artistic importance, which also included Virginia Woolf, Maynard Keynes, and Roger Fry. The adults at Charleston always seemed to be ensconced in the studio, so as children we would gravitate to the kitchen, where Grace, the housekeeper, held court, or to my father's pottery, where we would try to throw ambitious pots. If these were considered good enough, they would then be fired and we would be allowed to paint them.

Vanessa and Duncan had decorated most of the walls and furniture at Charleston with colorful paintings and there were also pillows, carpets, and drapes to their designs. These I found particularly thrilling as I have always liked the idea that everyday practical objects should also be things of beauty. This must have had some bearing on my first childish interest in design, and as I grew up I was increasingly keen to join in. Olivier encouraged me to start dressmaking when I was very young, and when on vacation, I took up sketching in imitation of my father. The painted environment which surrounded me encouraged me to think that I could easily paint things too. I was only seven when I embarked on decorating a chest of drawers and stool to match, and

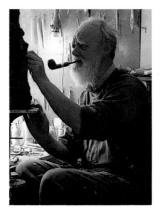

My father, Quentin Bell, looking typically exasperated while working on a sculpture in his studio.

Opposite: The fireplace in the Garden Room, painted by Duncan Grant. As children we were not encouraged to go into this room, but I always thought it particularly beautiful, and still do.

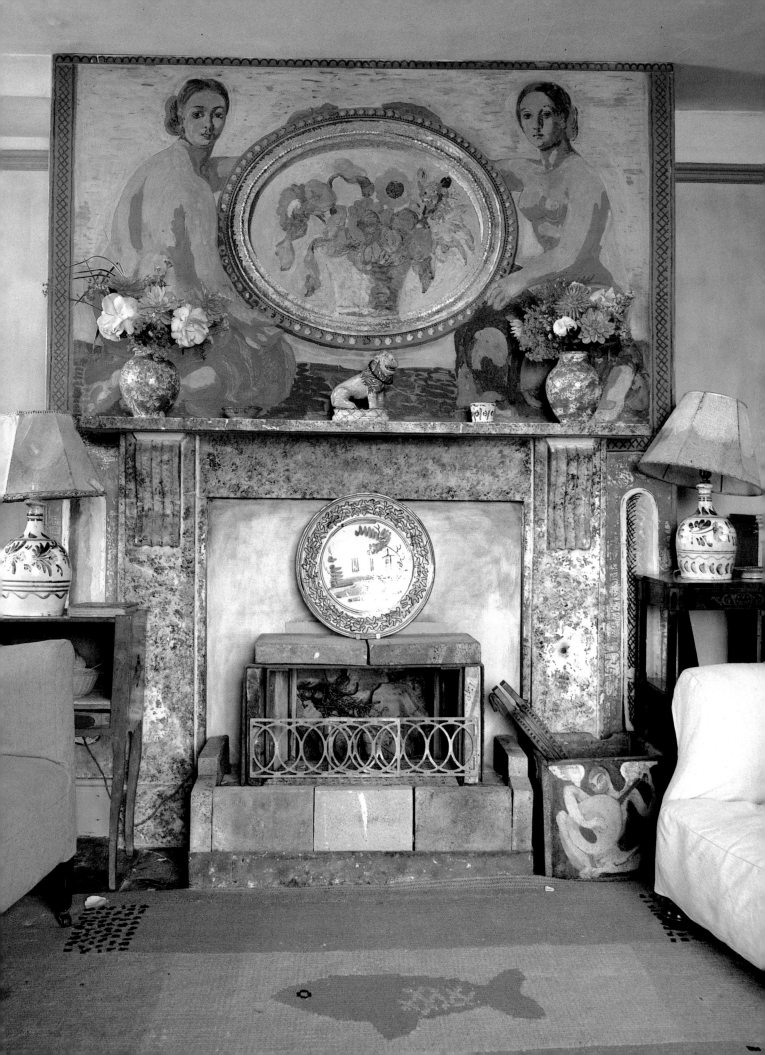

An early attempt at a home-printed fabric. This was created using a small picture-frame stretched with silk and blocked out using shellac. In place of a craft squeegee I used one intended for cleaning car windscreens.

by the time we moved house a year later I was insisting on painting my own bedroom.

My interest in textiles must have been due both to the influence of Charleston and to my love of clothes. Choosing the cloth to make our dresses had always been a source of great excitement. Olivier would suggest all sorts of interesting fabrics, African and Indian prints, William Morris furnishings, dazzling colored silks, in fact anything new or different. It soon became my great ambition to make my own textiles. However, this was not to prove so easy, as the equipment and expertise needed were not available at home and I had to wait until I learned printing at high school.

We had an excellent art department, where I was taught block and screen printing and was allowed to print more-or-less whatever I liked. The results were pretty appalling in retrospect, including a hideous palm-tree print (which I loved and hung on my wall) and an uninspired rose repeat which I made into a skirt.

By about age thirteen, I had decided that I wanted to go to art school, if possible to study some sort of applied art, such as textiles or graphics. Having this ambition made the intervening years very enjoyable as I did not need spectacular exam results to achieve my goal. However, I did stay on to graduate, so as not to be thought stupid, and I printed one of my first scarf designs for the art exam; it was entitled "Fecundity" and was based on Brussels sprouts plants. I passed without flying colors.

MY MEDIOCRE RESULT in my art exam proved a bonus at the first art school I went to, as those who had done well were singled out and given a hard time. My "Bloomsbury" background, however, turned out to be a bit of a drawback. Suspecting this might be the case, I had decided to keep silent about it, but a professor got wind of the facts and scathingly announced that I was one of "those" Bells, implying that I belonged to some exclusive and arrogant group. I felt very embarrassed and decided it would be better in future to be totally honest before anyone had a chance to catch me out.

After this foundation course, I took a fashion and textiles course at St Martins School of Art which I

Textile designs produced while at St Martins School of Art. They show my experimentation with a range of styles, from the freely drawn scarlet ibises at the top, to the heavily worked and encrusted "heirloom" project below, to the meticulously stenciled necklace design at the bottom.

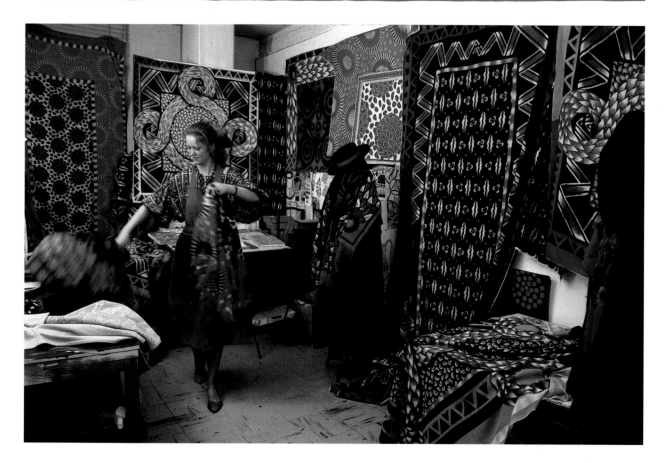

enjoyed tremendously. The fashion students prided themselves on dressing up in all sorts of weird and wonderful guises, with mounds of huge jewelry, elaborate make-up, and hats of every description. I learned a lot about fashion – as much from my peers as from my professors, but I was not particularly good at it, so I decided to specialize in textiles.

The course involved a period of work experience, which was a turning point for me. I worked for a small design company near Como in Italy, and was shocked to discover that not every design involved sitting down to draw something from life. Instead, I was given reference material and told to "do something a bit like this" as there was no time for original research. I was also surprised to see how much work I could get through when I had to, and decided that I would work as hard for myself on my return.

The other breakthrough came at the suggestion of a visiting lecturer who had noticed my sketchbook. By

My studio space at the Royal College of Art, just before the final show. This picture shows most of my collection, including four huge printed panels which took almost a week each to finish. I also produced three outfits complete with printed coats, scarves, and even hats.

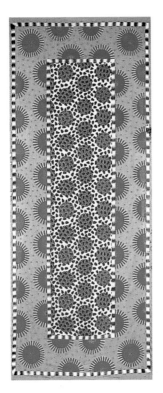

nature, I am a meticulous and neat designer but I had developed a very loose style in fashion-drawing classes, to get around my antipathy for the subject. She suggested I should work on that style and bring all the blobs, cross-hatchings, and wiggly lines into my textiles. The resulting final collection was very different from my previous work and is probably far closer to the Bloomsbury style than anything else I have done.

Attending the Royal College of Art was literally a dream come true. However, it came as something of a shock to the system to be back suddenly at the bottom of the heap and struggling with all the new competition. It was certainly worth it, though. The teaching was rigorous and the atmosphere very hardworking, though enjoyable. The designs I produced became more consistent while keeping much of the new fluency I had acquired. I still think I printed some of my best textiles while I was there and did not have the worries of running a business to constrain me. As a working designer, however, I have managed to complete many projects and commissions that I have enjoyed immensely and have also been proud of.

A three-meter length from my final show at the Royal College of Art. I have reworked this pattern since then to produce a square scarf and a carpet.

PROBABLY THE MOST glamorous commission I have ever received was from clients in Virginia. I received a phone call and within a week I was sitting in a helicopter for the first time in my life, flying to their home near Charlottesville in the Blue Ridge Mountains. This sort of thing is undoubtedly fun, but also nerve-wracking, as I had just one day in which to come up with pages of ideas for the redecoration of several rooms. My clients were avid collectors of Bloomsbury paintings and wanted a decorative style that would enhance their collection. In general, I avoid following in the family footsteps, but if Bloomsbury pastiche is called for I would prefer to be the one who does it. Luckily, they liked my proposals and I was engaged to return a few weeks later having printed their drapes, throw, upholstery fabric, and pillows.

On my next visit to Charlottesville, I stayed for one month and worked for seven days a week. I had the house more-or-less to myself, so it was quite a lonely task. I decorated a bathroom and adjacent sitting room

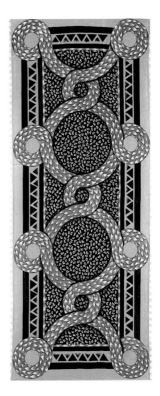

Another length from my first show based on a design found on the floor at the Victoria & Albert Museum in London. This took almost a week to finish as it involved elaborate spraying techniques.

Opposite: A detail of some of the decoration I did in Charlottesville. This shows a window shade painted with a vase of flowers, a wooden door, and panels decorated with leaves and a speaker disguised as a bunch of grapes. A 'Flower Vase' cushion completes the organic theme.

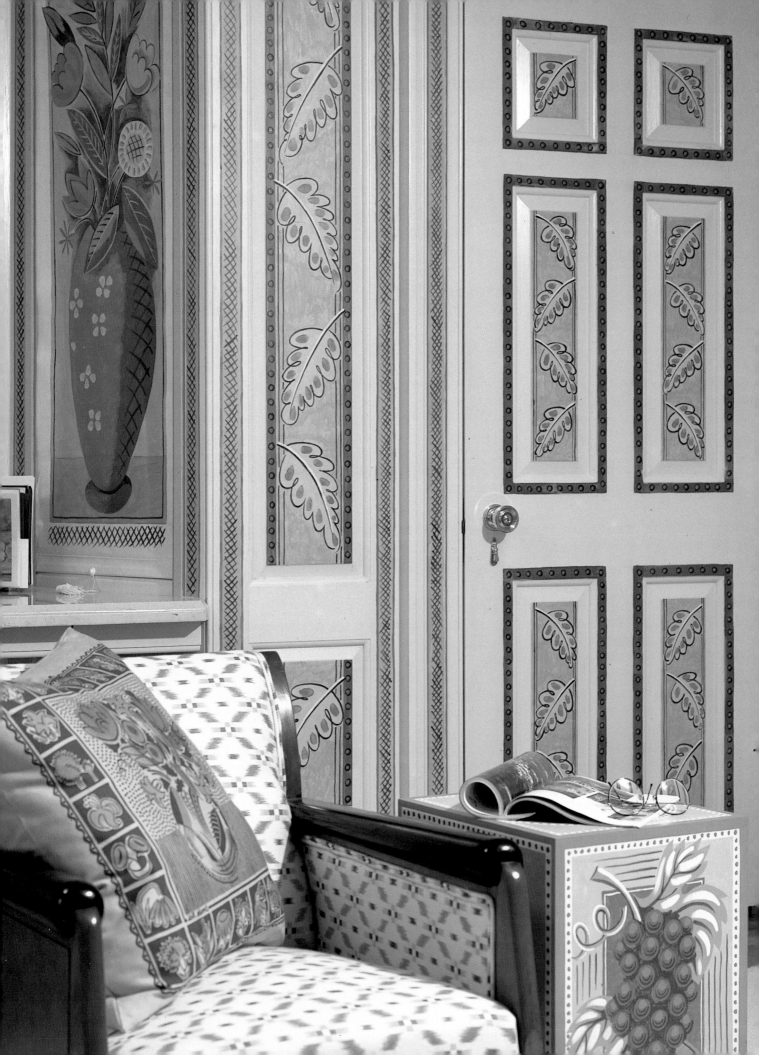

My preliminary sketches for the decorations at Zoo Studios, with a few scribbled suggestions for making them more zoological. Instead of my normal spots and stripes, I ended up painting fish, birds, and tiger eyes on top of the green camouflage pattern.

very much in the Bloomsbury style, with painted walls, closets, and shades. I also disguised a pair of speakers as tables and decorated a monolithic pop-up television cabinet. The drawing room was painted with the pattern from the walls of the garden room at Charleston, and I decorated the grand piano with a grandiose design of my own invention, complete with wreaths, trumpets, and other musical motifs.

It took two more trips before the list of things for me to do ran out, by which time I had also painted a study, a bedroom, two desks, a dining table, a display cabinet, a sideboard, two picture frames, an ottoman, a coffee table, a wardrobe, five bedside tables, two plant pots, and a gun cabinet. I had also been flown in a private jet to Florida for a week and treated to sun, sea and speed-boating, so it was not all hard work!

Another, more recent commission was to decorate a London recording studio called Zoo. When I was first approached about this project I thought it was definitely not for me. Here was a client wanting to build a recording studio for the advertising business which would appeal to a young clientele with a taste for fashionable night-clubs, and I did not think I was really up to it. Zoo Studios was to have an animal theme, and needed some eye-catching decoration for the reception area as well as fabric to cover the soundproofed walls.

I was rather timid about producing figurative animal designs so I searched out an old sketch-book of drawings made at the zoo and abstracted some patterns from these. The results were surprisingly successful, and after a couple of modifications, to give them a more animal quality, it was decided that I should paint two of the patterns directly on to the reception-area walls. This required working out a huge repeat for one design and tracing it on to the wall in stages before painting and stenciling in the details. The other pattern was more random, and was painted over sprayed shades of green. This meant masking out all the surrounding walls, floors, and ceiling and hiring an industrial-size spray gun. I ended the day with a fine mist of dark green paint all over my clothes, in my ears and nose, and all through my hair! The end effect was something like being in a jungle or aquarium, and we were all very pleased with it.

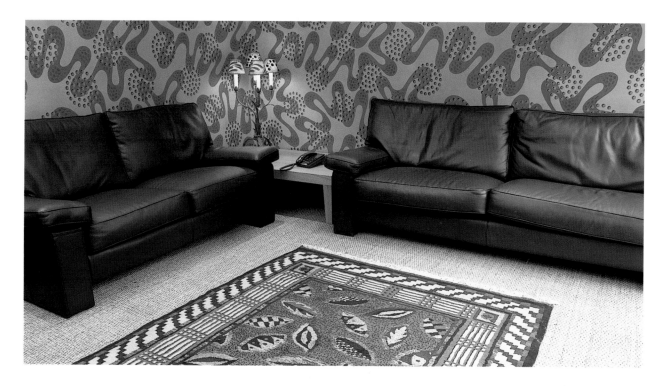

This sort of treatment would not have been possible for the soundproofed walls, so in the end it was settled that I would dye the fabric for the two studios and print quite simple animal repeats. Luckily the recording-studio venture has been a great success, and as it has expanded I have had to go back to paint another room in a new version of the green sprayed design, with little red fish swimming all over it.

I am fairly accustomed to working on large projects such as Zoo Studios, so I tend to treat all my designs as separate and major pieces of work. This means that I find it extremely difficult to sell textile designs on paper as they do not fit readily into other collections. However, it works to my advantage when I am commissioned to create a design with a specific theme and purpose, as I am used to working to detailed instructions so I can understand a client's particular taste and needs.

The commission for a Suleiman the Magnificent scarf for the British Museum could hardly have suited me better, as I am a great admirer of Turkish designs and often make use of them. I came up with two sketchbook ideas, both based on the pottery displayed in the museum and incorporating slightly different styles; the

The reception area at Zoo Studios. I painted the lampshades to match the green jungle design on the adjacent walls, and the carpet is one I designed for Chris Farr, which just happened to fit the theme.

choice was theirs. The end of my involvement was to paint the one chosen to full scale and let the museum get it printed.

Sometimes I do get involved in the printing as well as the design. This was the case with a scarf I produced for the Victoria & Albert Museum, to go with their Sovereign Exhibition. They gave me numerous pictures with royal themes from which to work and I put together three or four ideas. We worked together on their favorite one to include a few more patriotic themes and I was entrusted with the printing. It was produced in several colorways and two styles – a large woollen shawl and a small silk scarf – which went into their Christmas catalogue.

For individual customers who do not want to commission an exclusive design, I quite often print existing designs to order. This way they can have a specially designed colorway printed on the fabric of their choice to match whatever decorative scheme they have in mind.

Designing a carpet seems at first consideration to be an obvious progression from designing a scarf. They both have to be self-contained designs, with a central area of pattern, and possibly one or more borders. However, a scarf can contain highly detailed and curvilinear elements which you soon discover are impossible to incorporate in most carpets owing to the size of the knots. Hand-woven carpets are worked out on a grid system and if the knots are the size of a lentil you cannot expect any small imagery to come out clearly.

When I first started designing for Christopher Farr in London, I was determined to get as much detail as possible into my carpets and I perplexed him by continually ringing up with queries about knot size. When I delivered my designs I also brought along my own plans of how they would work, knot by knot, without which I am sure I would have been told that they were impossible to execute. The designs were sent off to Turkey to be made, and six months later I had the immense thrill of seeing the finished carpets, just as I had designed them and beautifully made.

Since then I have designed several more carpets, both as individual commissions and as limited editions. I try to keep them slightly traditional, combining some

Sketchbook pages showing ideas for the Suleiman the Magnificent scarf. I spent twenty minutes taking pictures and then went back to the studio to do the rest, developing two themes from the different styles of pottery. The design at the top was chosen.

Two of my suggestions for the V&A's Sovereign scarf. The yellow and red one was chosen, though we also produced it in the blue, black, and gold colorways. I have yet to find a use for the rather grandiose swags of the other one.

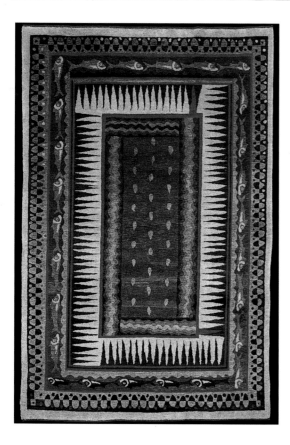

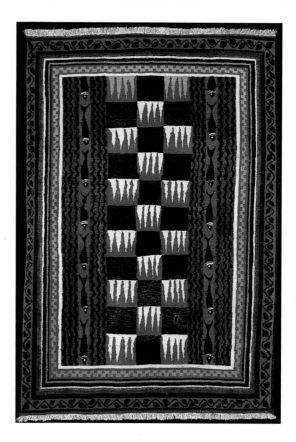

familiar styles with my own personal design vocabulary. An example of this can be seen in two of my rugs which were inspired by garden carpets with their rivers and small gardens with birds, fish, and animals. Others are closer to my own textile designs, but many of these are in turn influenced by Turkish fabrics so that the traditional feel is retained.

As well as commissions for large or long-term projects, much of my work involves smaller, private requests for painted furniture, lamps, lampshades, and illustrative work. These are also a challenge as usually I must work to instructions and take into consideration specific colors or themes, albeit on a smaller scale. I have painted a number of unusual items, such as a coal-bucket, three music cases embellished with theatrical and musical motifs for an opera singer, and a puppet theater commissioned by my brother-in-law.

The puppet theater was a very enjoyable task. There was no need for elegance or subtlety, just glorious bright color and fairground *joie-de-vivre*. The theater

Two fish carpets designed for Chris Farr, inspired by traditional garden carpets. The one on the right has a check and zig-zag center representing little garden patches. I have designed two more fish-patterned rugs to match this particular carpet for one client, and a matching lamp and lampshade for another.

Custom-made wedding invitations. Each includes emblems and symbolism special to the people involved, and has multiple uses, such as for a table marker, menu or place card.

consists of three doors, providing perfect frames for each panel, which I decorated with a sun, a moon, and a design of theatrical masks. Turned wooden banisters flank the stage, decorated with barber's pole stripes. To finish, I made red velvet drapery edged with gold metal fringing.

More usually, I am asked to paint tables, chairs, and lampshades, often to match a particular color scheme or one of my carpets. I try to get a general idea of what is wanted and then draw some suggestions in my sketchbook. Any rejected ideas can always be re-used for another project; I do not like to waste designs and I quite often adapt them for other uses. The most difficult thing is when I am given a free rein and asked to produce "something beautiful" and not worry about having it approved before I start. There is then a rather nerve-wracking wait to see what the client thinks of my suggestions and designs.

Over the years I have designed a lot of cards and invitations, mainly for my own private views and open evenings, and I really enjoy this sort of illustrative work. They are usually black-and-white line drawings which are printed onto card and then hand-painted in colored inks. A spin-off from this has been designing cards for other people. I have been asked to produce quite a few wedding invitations and menus where some special symbolism that is personal to the bride and groom is required. One invitation was inspired by a favorite children's book illustration showing a princess's tent of gold starry fabric, which I then printed on silk to use as an awning at the wedding. Others are quite obviously romantic, with trumpets, cherubs, hearts, and curlicues. These are fun to do and make very nice keepsakes; I have even painted a special bookbinding to match, for the wedding photo album.

AT THE TIME of writing, my business has been running for eleven years. Immediately upon leaving college, I set up a company with Christine Miles, a schoolfriend of many years who has both artistic sensibility and a firm grip on management skills. Amazingly enough, we are both still in business together, and still friends. The main activity of the business has been to produce at least two

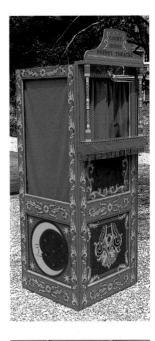

The Court House Puppet Theater.

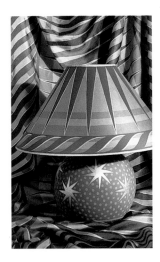

Hand-painted starry lamp and lampshade, photographed in the store against a "Navaho" print scarf from the winter 1994 collection. The selection of lamps and lampshades is ever-changing and to reflect the newest colors and designs we have in stock.

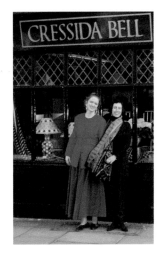

At the store on opening day with Christine

collections of hand-printed scarves and shawls every year. For many years we did the rounds, lugging a heavy sample case to show to the buyers in the various department stores and boutiques, which can be a fairly soul-destroying business. We decided that it might be a good idea to diversify into the field of interior design and decoration, and this has generally been more successful. We also started to hold more frequent open evenings.

We had always known that people enjoyed coming to look around the studio but were surprised to find that the more events we held, the better we did. The logical conclusion was that we should open our own store or showroom, but it was some time before we were offered suitable premises. Now that we have a store, it has proved a great help, as clients no longer have to struggle through the back streets of the inner city to find us and there is always stock on display instead of hidden away in closets and sample cases. We keep an ever-changing range of around twenty-five different designs on screen. As we can print them in a huge range of colors and fabrics, it has never been possible to produce a comprehensive catalogue. We also keep a large stock of painted pottery, lamps, and lampshades, as well as a selection of pillows, neckties and, handkerchiefs. I now have the luxury of being able to paint a lamp or lampshade on a whim to put into the store, whereas before it seemed like a waste of time.

We still have the studio and produce a winter and summer collection of scarves each year, while recycling the more popular existing designs. It is sometimes difficult to fit in the time to design our own collection as well as all the work I produce to commission, but it is very satisfying to print a design for the first time and to experiment with colors and fabrics.

I am always keen to take on new and different work but my favorite activity is still designing. Using textile design as a starting point is not a limitation; it allows you to deal in almost any other kind of decoration, and the possibilities are endless. I have been asked if I might run out of ideas, but that seems unlikely given the immense variation that can be culled from even the simplest of themes. I hope this book will suggest a few of these and act as a starting point for aspiring designers.

GALLERY

I intend the following pages to be both interesting and useful. As I have introduced myself as a textile designer, I thought you might care to see a few of my fabrics. Most of these pictures show details of scarves and shawls produced since 1984, but I have a tendency to rework my own designs so you may recognize similar motifs recurring in the projects. I hope you will enjoy looking at this selection of my work and may also find it a source of inspiration for your own decorations.

Cactus print scarf design.
Latex paint on paper. 1985

Tile print repeat design.
Latex paint and dye on paper. 1986

Previous pages: Exotic Fruits scarf design.
Latex paint and dye on paper. 1991

Untitled repeat design.
Latex paint and chalk on paper. 1987

Architectural Lattice repeat design.
Latex paint on paper. 1985

Opposite: Wave print scarf.
Acid dye on silk twill. 1986

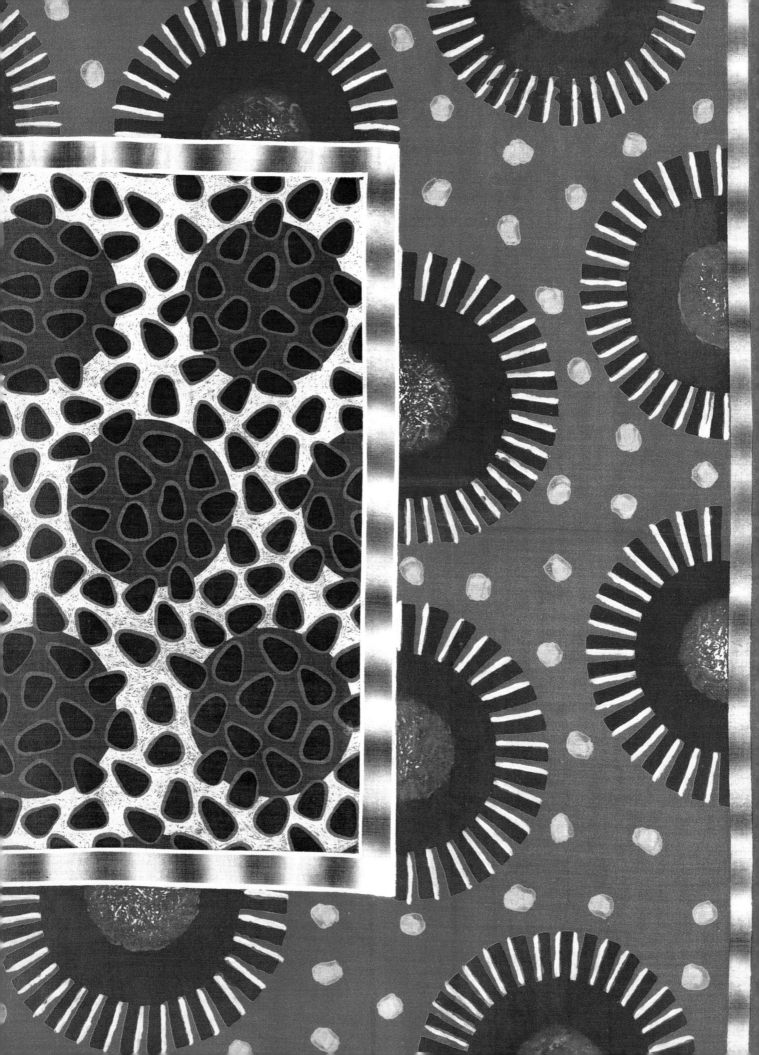

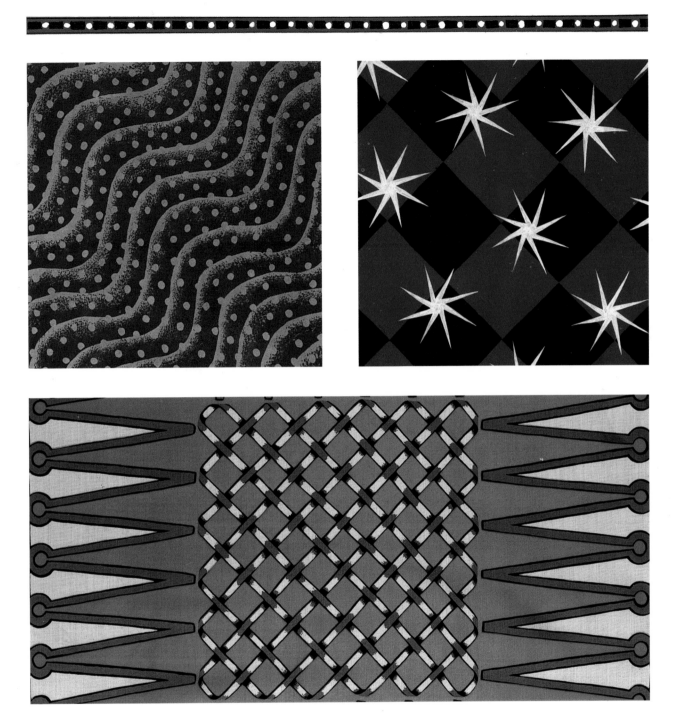

Top left: Wave print scarf.
Acid dye and discharge print on wool, 1984

Opposite: Sunrise print scarf.
Acid dye and discharge print on wool, 1984

Top right: Stars and Bars print scarf design.
Latex paint on cartridge paper, 1988

Below: Lattice and Zigzag print scarf.
Acid dye print on wool, 1986

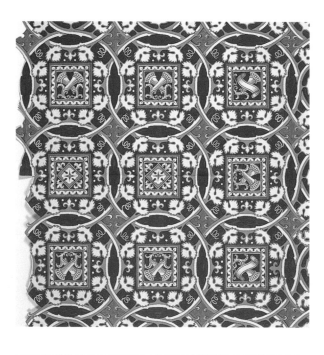

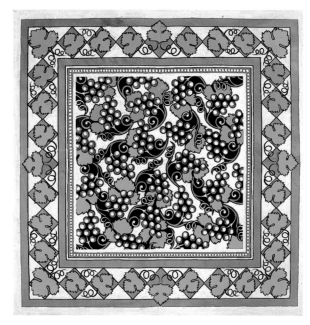

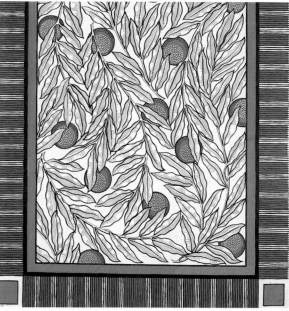

Tendril print scarf.
Acid dye on silk. 1989

Grapes print scarf design.
Latex paint and dye on paper. 1988

Vine Trellis print panel design.
Latex paint and dye on paper. 1991

Oranges print scarf design.
Latex paint and dye on paper. 1988

Opposite: Baroque Window scarf design.
Latex paint and chalk on paper. 1987

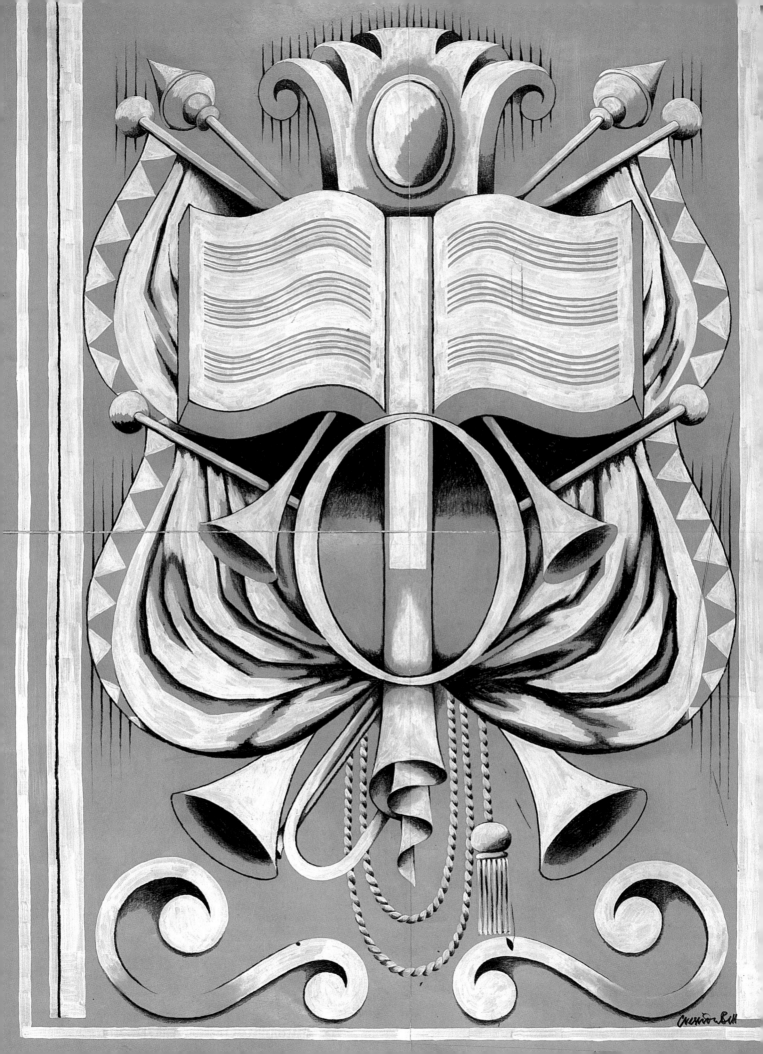

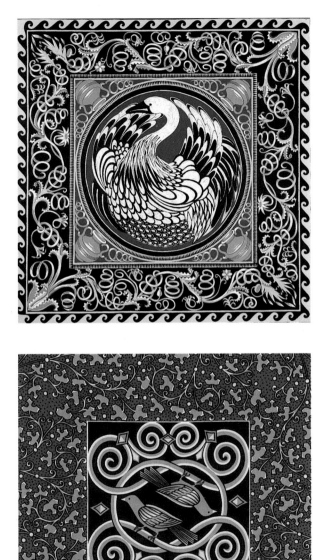

Swan print scarf design.
Latex paint on paper. 1989

Nightingales print scarf design (detail).
Latex paint on paper. 1989

Opposite: Baroque Music scarf design.
Latex paint and charcoal on paper. 1987

Columbus print scarf design.
Latex paint and crayon on paper. 1992

Baroque Leaf scarf design.
Latex paint and crayon on paper. 1987

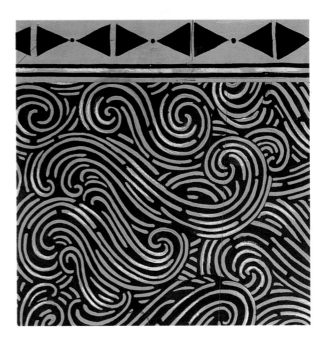

Carnation print design.
Latex paint on paper. 1985

Circles print scarf design.
Latex paint on paper. 1985

Parquet print repeat design.
Latex paint and crayon on paper. 1986

Spaghetti print scarf design.
Latex paint and chalk on paper. 1986

Opposite: Leopard print scarf design.
Latex paint on paper. 1989

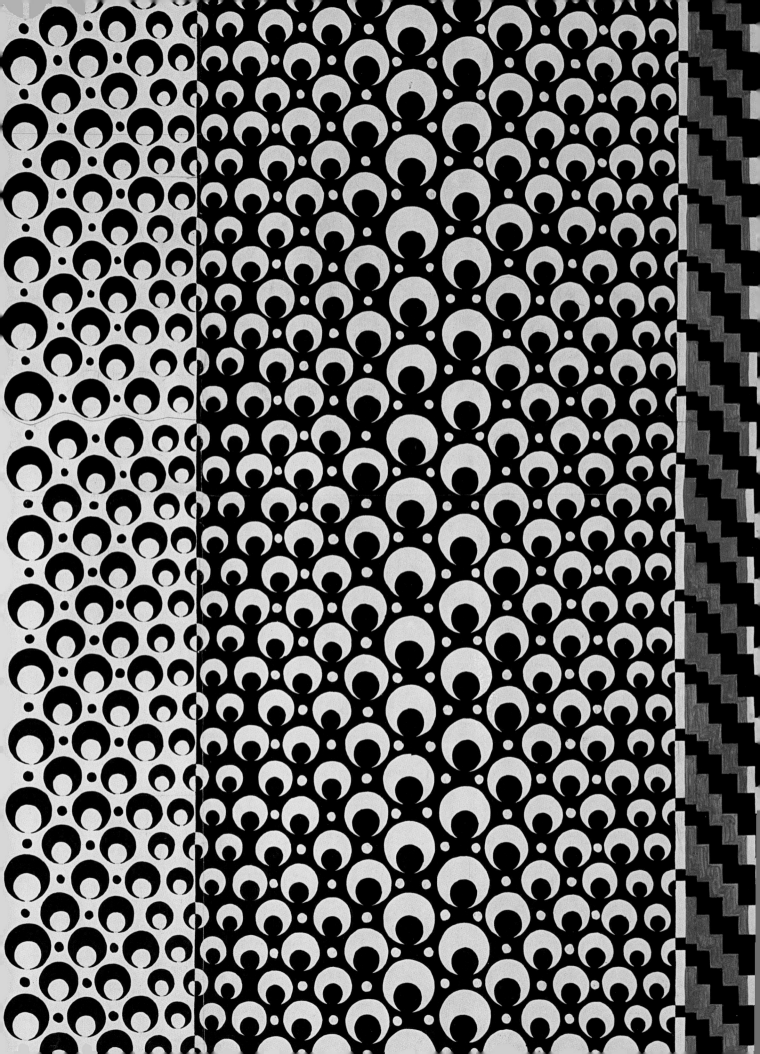

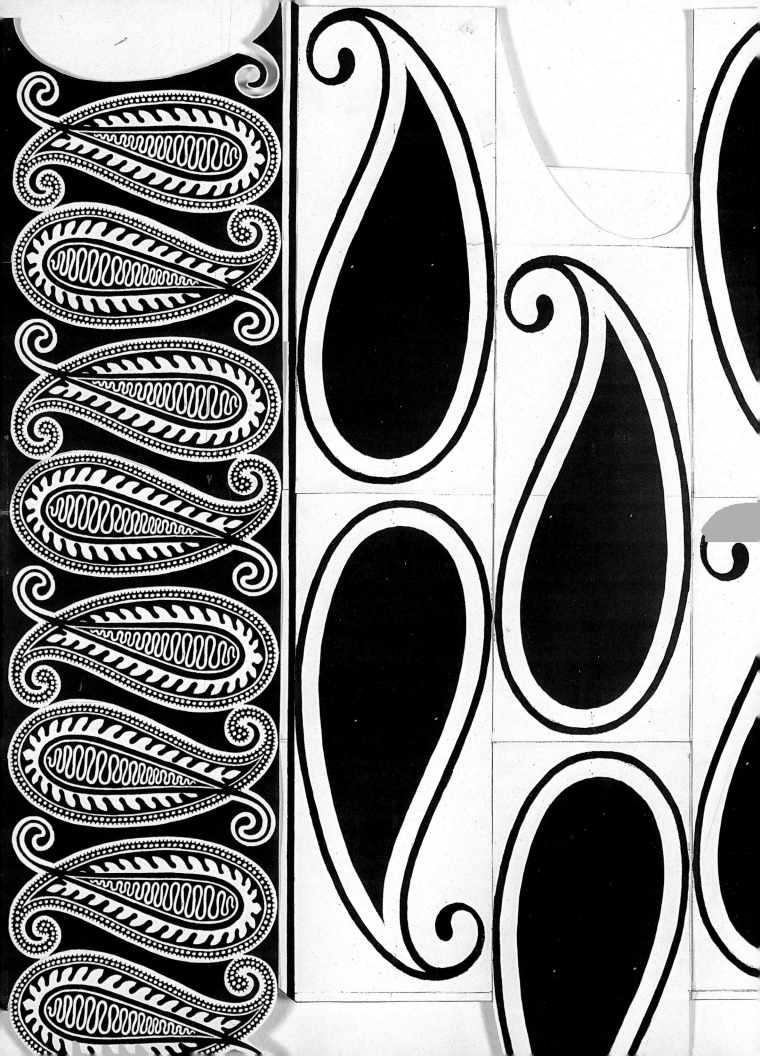

TOOLS & MATERIALS

*The projects in this book rely on a very basic tool kit, much of
which you will either have already or be able to buy inexpensively.
There is seldom any need for elaborate techniques and those used
should be a means to an end, not an end in themselves. I am
inveterately slapdash and am very likely to take short cuts as
I believe in instant gratification whenever possible. However, there
are a few useful points to be made here which I recommend you
read before embarking on the projects.*

tools and equipment

Working more or less counterclockwise from the top left-hand corner, this shows the basic equipment needed to complete the projects in this book.

One yardstick or meter ruler . *Useful but not essential for drawing and measuring long straight lines.*

Steel straight edge. *For cutting against.*

Color chart.

Decorator's brush, 7.5cm (3in) wide. *For painting large areas of base coat.*

Decorator's brush, 4cm (1½in) wide. *For painting smaller areas of base coat.*

Grader's set square (marked in cm/⅟₁₆in). *For measuring and drawing out designs (see following pages). A transparent plastic ruler marked with parallel lines may be used instead.*

Soft, clean eraser. *A constant necessity. Keep it clean so it does not smear.*

Masking tape, 2.5cm (1in) wide. *Try to buy "lowstick" if possible.*
Masking tape, 1.25cm (½in) wide.

B or 2B pencils. *Soft pencils make darker lines and are easy to erase.*

Old, worn brush for mixing and trying out colors. *An old brush is best for mixing and testing colors.*

Hog bristle artist's brush, medium. *Those made in China are least expensive and best.*

Flat artist's brush, 2.5cm (1in) wide. *For painting wide bands or areas of color.*
Flat artist's brush, 1.5cm (⅝in) wide.

Round artist's brush, medium. *When using latex paint, it is best to choose natural*
Round artist's brush, small. *rather than manmade fiber brushes – squirrel will do. Wash frequently, as the paint clogs and destroys them very easily. N.B. You will probably find that you end up using only one favorite round brush that makes a good point and has no stray hairs.*

Craft knife with snap-off blades. *For cutting templates and sharpening pencils.*

Spare blades.

Selection of coins for drawing round templates.

Sketchbook, templates, and designs.

Water-based pigments. *These pigments are used in textile printing and for coloring latex paints and are not generally available in art stores. Watercolors may be used instead.*

Paper towels for cleaning and wiping. *Indispensable for wiping brushes, removing mistakes, and cleaning your hands.*

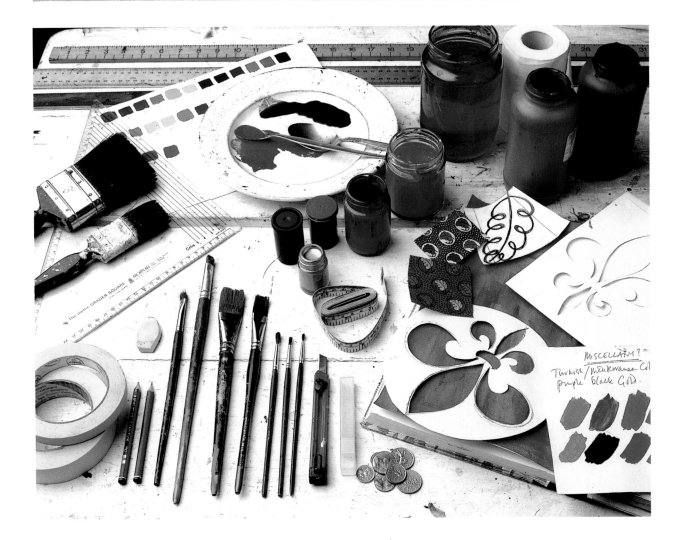

Mason jars.	*For decanting from a large can of latex paint.*
Film canisters.	*To keep small quantities of colors you have mixed yourself.*
Water jar.	*Make sure you change the water frequently.*
Old plate and spoons.	*Reserve a plate or dish for this, as paint and dye do not wash off completely.*
Gold paint.	*Use water-soluble gold paint so it does not come off with the varnish.*
Tape measure.	*Marked in inches as well as centimeters.*

For some of the projects you may also find the following necessary:

An apron or overalls; pale-colored chalk or pastel; scissors.

At the start of each project, I have given rather scant instructions about preparation. This is because I feel that the amount and quality of preparation are a matter of personal choice. My first instinct is to forget prepping and get on with the "fun" bits. Needless to say, this is not good advice if you want the best finish and an item that stands the test of time. Maybe the slapdash approach was bred into me; my forebears were pretty negligent in their attitude to preparation, which made the task of those who restored the Charleston farmhouse very difficult.

Ideally, when painting old furniture, you should sand or strip the surface to remove old paint and varnish. Any filling should also be done at this stage, before applying primer. Walls should be washed down with a low-foam detergent to remove grease and grime, and all other items to be painted should be clean and dry before you start.

PAINTS

My favorite medium is always latex paint, even for painting designs onto paper. The specific colors used in these projects are listed at the back of the book, but in general I buy a few basic colors in large cans and mix them with water-based pigments to achieve the colors I want. These pigments are not readily available in craft stores but may be obtained from specialty stores. Alternatively, you can buy a selection of ready-mixed latex paints, combining them to vary the shades or adding watercolors or gouache to small quantities of the paint to change the color. Keep these home-mixed colors in Mason jars or film canisters for future use, so that you build up a collection and do not always need to rush out and buy more.

It is easy to paint with latex as it is water-soluble and dries quickly, which is very helpful when painting complicated patterns. You may find that it is rather thick, in which case dilute it until it flows easily from your brush, but not so much that it does not cover well.

Gold paint is often used in the projects. I use a powdered gold which I mix with a painting medium myself, but there are many pre-mixed gold paints available which will do just as well. In either case they need frequent stirring, as the gold in suspension tends to sink to the bottom.

VARNISHES

Although the paints I use are washable, it is wise to add a protective varnish of some sort to most items. Quick-drying, water-based coatings are available which look milky but become transparent when dry. More hard-wearing are the polyurethane varnishes which come in interior and exterior qualities and can be low-gloss, satin, or high-gloss. I like a low-gloss or matt finish, which is what I specify in the projects, but use whichever you prefer. Note that varnish has a slightly yellowing effect which increases with time.

DRAWING AND MEASURING

Once you have painted the base color, most of the projects require you to draw the design in pencil. This

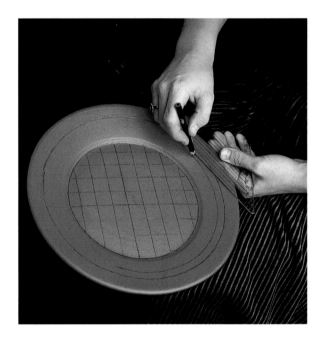

1. *Using a set square to draw parallel lines. Place the set square so that you can see your line through it. Use the edge to rule your parallel line at the distance shown by the calibrations marked on the set square. When following a curve, draw only short lines and move the set square around frequently.*

requires quite a lot of measuring and drawing of lines. Much of this can be done by eye when you get used to it, but I find the use of a pattern cutter's set square, or grader's square, invaluable. One marked out in centimeters is the most useful; it has a set of ruled lines down one side at 0.5cm (³⁄₁₆in) intervals, up to 6cm (2¼in), which enables you to draw parallel lines at various distances. It also has a line at right angles bisecting the set square, with measurements marked outward in each direction. This enables you to measure equidistant objects from any line, mirroring a pattern from one side of the line to the other, and you can mark right angles with great precision.

Once you become accustomed to this tool, you will find it immensely useful, but if you are unable to obtain one you can use a clear plastic ruler which has parallel lines marked on it instead. You will still need a square of some sort if you need to make a line at right angles, but it should suffice for your needs.

Use a soft pencil (B or 2B) for drawing the pattern, as it shows up well and erases easily. Mistakes can often be made at the drawing stage, when a particular image does not fit in exactly or a measurement is wrong. I keep an eraser on hand at all times and adjust the design as I go along. If you end up with a really dirty mess, you can always use paint to obliterate the offending marks.

For painting areas bounded by straight lines I quite often suggest using masking tape to give a straight edge, rather than relying on a steady hand. This works fine as long as you are painting on a sound base, but sometimes the tape will pull a layer of paint off with it when it is removed. Use lowstick masking tape and never leave it on for longer than necessary, particularly in hot weather, when, as I know to my cost, it can even take lining paper with it. This is rather dispiriting and the only solution is to patch it up as best you can afterward.

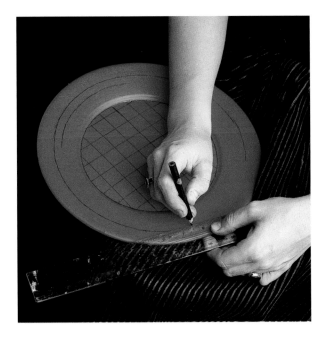

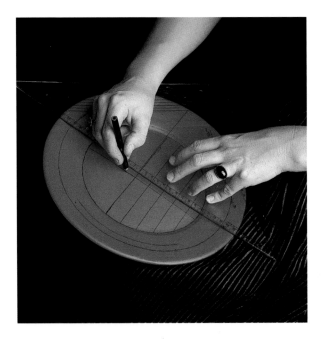

2. Using a ruler to draw parallel lines. This is done using the same technique as with the set square. The ruler may not be marked with the appropriate calibrations, in which case you will have to mark the measurements first and find the nearest approximate lines on your ruler.

3. Using a set square to make checks. Draw parallel lines at equal intervals in one direction. Looking through the set square, line up the right angle on it with one of them. Use the long edge of the set square to rule a line at right angles, then complete the pattern with more equidistant parallel lines.

This book supplies you with sixteen pages of templates, some of which are necessary for the projects and others which are there for you to use in any further projects you may wish to pursue. You may well be able to use some of them directly from the book but others may need cutting out in stages or adjusting in size for use in the projects.

ENLARGING ON A COPIER

The most important change that will be needed will be that of scale. This may seem like a problem but can be dealt with very simply with the help of a photocopier. All that is needed is some very basic math and a calculator. I suggest you work in centimeters if at all possible, as it is far easier. Taking the sun motif painted on the dining chair as an example, the template supplied is 8cm (about 3in) in diameter, which works for the back of my chair, but may be too large for yours. You may need, for instance, to decrease its diameter to 6cm (2¼in), using a photocopier. Photo-

copiers work in percentages, and it is best to work out beforehand by what percentage smaller or larger the templates should be. To find this, divide the size you want (6cm) by the size you have (8cm) and multiply the result by 100 to achieve a percentage: ie, $6 \div 8 = 0.75 \times 100 = 75$. In other words, 75 percent of 8 is 6. If the percentage is longer than three digits then round it to the nearest figure. This calculation works every time, but if the figure is more than 200 percent, you will need to enlarge the image in stages as most copiers will not enlarge by more than this.

Once you are happy doing this calculation, you will find it very helpful whenever you need to adapt a pattern or change the measurements I have given to fit your particular needs.

SQUARING UP

If you have trouble with percentages and math, or you cannot gain access to a photocopier, you can enlarge designs by using the traditional method of "squaring

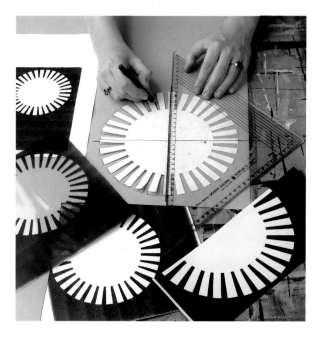

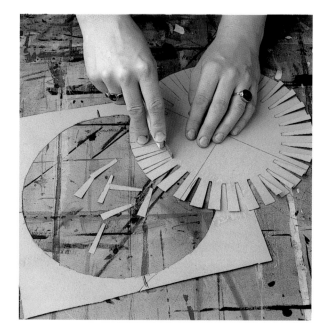

1. *A selection of photocopied templates showing different sizes and possible materials. Remember to transfer guidelines, as shown, when copying onto stencil card, as they are essential when positioning the template.*

2. *Use a sharp craft knife to finish cutting out a template. The circle was cut out first, then the radial lines, both with scissors. The last part is easier to cut with a knife as it requires sharp corners*

up." This method would also be useful for the window shade project, where the image supplied must be greatly enlarged. Draw a rectangle the size you want the finished design to be and divide it into equal squares. Rule a similar grid over the design to be copied, with an equal number of squares. Copy the image from each small box to each corresponding large one, adjusting as you go to match the lines. Using this method, you will find that it is much easier to keep the proportions right than if you try to copy by drawing freehand.

TRANSFERRING THE TEMPLATES

Once the image is the right size it may be necessary to transfer it to a stronger material. This depends on how it is to be used – most of the projects in this book need a temporary template to draw around, for which paper is adequate. Paper should also be used when you want to trace an image through from the wrong side, as it is slightly transparent. However, templates that will be used quite heavily should be on card; the light variety that will go through a copier will do, so that the copy itself can be used. Stencils should also be on light card as they have a tendency to tear, and those that are likely to get wet should be on oiled manila stencil card or even acetate. For card you would need to transfer the design from the original by copying, and for acetate you would transfer it by tracing.

CUTTING OUT

Consult the project instructions before cutting out the designs. They are used in different ways as indicated above and may need the internal shape cutting away for a stencil rather than the external one for a template. Cut out the templates and stencils with scissors, then use a sharp craft knife to cut the more detailed, fiddly areas. Before starting a project, identify all the templates you will need and make sure you have enlarged them and transferred them to card where necessary. This will save you time in the long run.

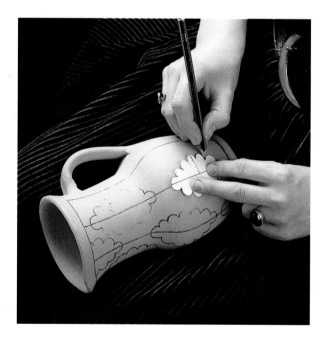

To work out the size of template necessary for the project it is best to start with educated guesswork. Try a rough template of about the right size and draw it on lightly to see if it fits, then adjust as necessary.

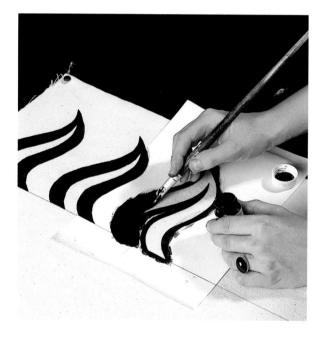

A stencil is simply a template cut out in reverse. Here, the area to be painted is cut out, leaving the background for support and as a positioning guide. Acetate or stencil paper would be more durable than the card used here.

When starting to design for yourself, do not be constrained by feeling that you must do something new or different. There is no doubt that whatever you do will have qualities intrinsic to you, derived from your particular arrangement of forms and choice of color. Instead of trying to be inventive, develop your personal style by visiting museums, galleries, and stores and looking around for patterns and colors that appeal to you.

Most designs and patterns are hardly original anyway, as almost all of them owe at least their inspiration to another source. Many of my own designs are arrived at by the rearrangement and adaptation of existing patterns, and the inspiration for them is drawn from a variety of sources. Even the most apparently complex and unusual-looking designs can be broken down into separate elements that have been plundered from elsewhere. Over the centuries, ornamental forms have evolved through constant reworking and reinterpretation. We need not continually go back to nature for every new tulip or carnation; more interesting results may come from adapting a previous pattern.

Illustrated here is a small part of my own collection of postcards and photos. Whenever I see any imagery that strikes me, I try to obtain a picture of some sort to add to my pile. The collection is not filed in any sort of order but is arranged in a higgledy-piggledy fashion for me to flick through when I need inspiration. I also refer to books, of course, when I need to find a more precise reference, but I enjoy the random ideas which these loose images turn up.

From this picture you can see how various different points of reference are pulled in to one design. The marquetry on musical instruments is combined with wrought-iron work in one scarf pattern, while in another the patterns on two plates are joined together by doodles of my own making, to form a black-and-white design.

I do not mean to belittle my own, or any other designer's, work by showing how it comes about. Everyone's work has its own personal stamp and it is through your own interpretation of a pattern that your originality shows. I love recognizing the same designs from all around the world and seeing how differently they turn out. Everything can change in the execution, depending on the scale, color, and medium used. If you are interested in creating designs for yourself along the lines of the projects in this book, then the following explanations may go some way to demystifying the design business for you.

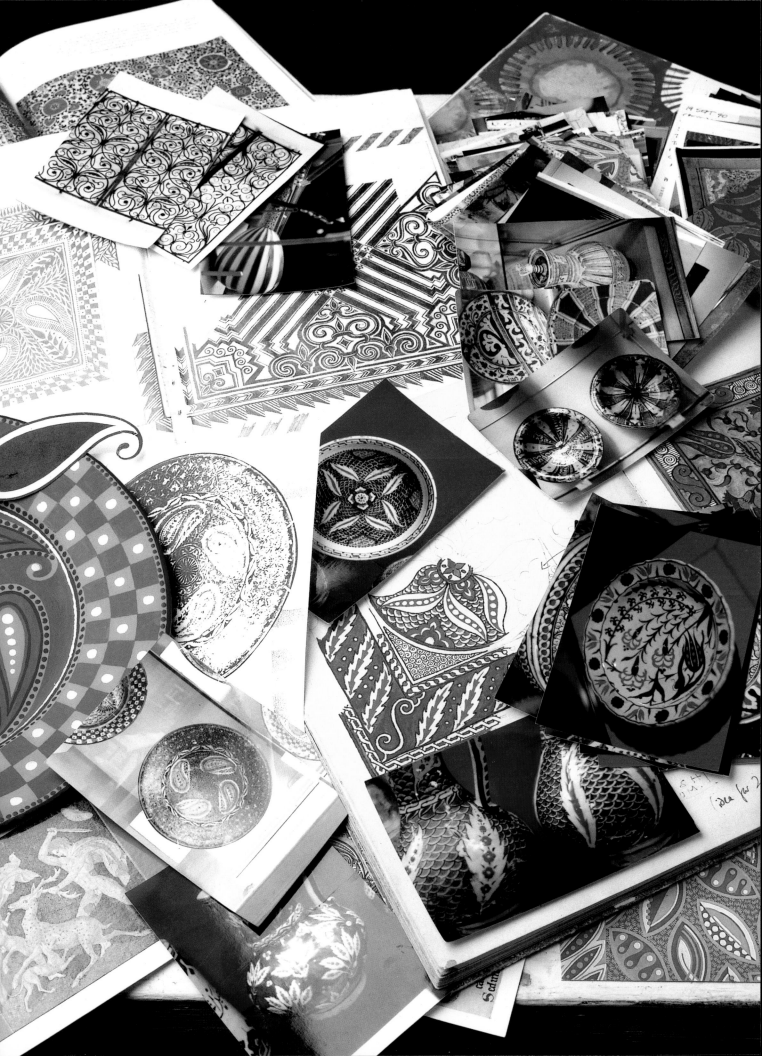

Once you have discovered a source of inspiration that you are keen on, there are many ways to go about using it. Firstly, it is necessary to capture the image in some way. This may be simple if it is in a book or magazine, or if a postcard is obtainable. However, you might find yourself interested in iron railings, architecture, or some forgotten artefact in a museum of which no picture exists. I strongly recommend the use of a camera for such research purposes, in place of the more traditional sketchbook. It is very difficult to capture all that you like about a design while struggling to hold a sketchbook, pencil, and sharpener, all the while being peered at and questioned by passers-by. Friends on vacation will be sitting in a café in the sun while you struggle in the museum trying to get that curly Corinthian capital onto paper. It is far better to snap away at anything that takes your fancy and then sift through the results when you get your photographs

back. There may well be something about the pattern that you would have missed when sketching. Use fast film, without flash, as many objects you like will be behind glass in dimly-lit rooms and it is useless and often forbidden to use flash. The final quality of the photograph is not important, as long as it is more or less in focus. In fact, I quite like an inaccurate photo as it leaves more to invention and thus helps to achieve originality.

Once you have your pictures in front of you, the next question is what to do with them. Consider their color, style, and form and spend some time with a sketchbook, doodling and playing with the images and colors you like. You will probably find that you develop your own vocabulary of decorative marks such as spots, zigzags, or loops. Keep all your ideas in a sketchbook so that you can flick through it for inspiration; you may find that a doodle rejected last time comes in useful later on.

If you do not feel confident about drawing from a photograph, you could use a photocopier instead. The simplest possible way to "borrow" a design is to enlarge it to an appropriate size and then trace it, or cut it out to use as a template or stencil. A tiny detail could be enlarged to form the main motif in your design, and no one would ever recognize the source. You could elaborate this method by using two or more designs together or by introducing counterpoint into the design. To do this, cut through the design with one or more straight lines and reverse the colors on either side of the line. This is a time-honored art-school exercise, and works extremely well.

To work out how you might use your design, start by making a drawing of the object you want to decorate, to scale if possible. Then work out how the pattern will fit by dividing up the space to make borders, stripes, or centerpieces. Draw on the design you want and try out your color ideas. There are bound to be some mistakes so it is always best to make them on paper first. Once you have settled on the design, you can scale it up with the help of a calculator and draw it straight onto your table, chair, or whatever, making any slight adjustments as you go.

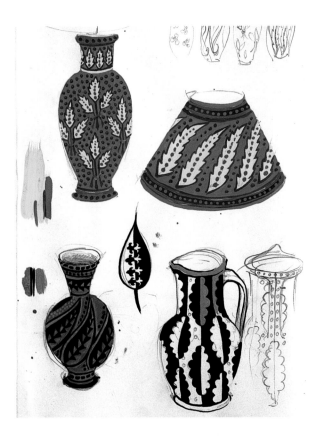

A page of my sketchbook, with various ideas for painted objects.

PLAYING CARD DESIGNS

The two designs shown on these pages illustrate quite clearly how I have borrowed from everyday imagery in my own scarf designs. The red, white, and blue design, with its clubs and diamonds patterns, is obviously based on playing cards. It is arranged very much like the traditional king of spades but without the heads and hands and the pattern continues to the edge of the scarf. The other design is further removed from the source. It is a huge, oblong shape, with a continuous herringbone pattern in the center, derived from the backs of cards. Superimposed at each end is a grandiose diamond, with smaller diamonds arranged between. The border continues with a more complex diamond design, edged with medallions from Italian playing cards, and so less familiar.

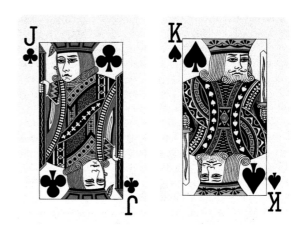

Below: Two scarves designed in 1992: "Diamonds" (on left) and "Clubs". These borrow quite obviously from the familiar multi-colored patterns usual on Royal playing cards (above).

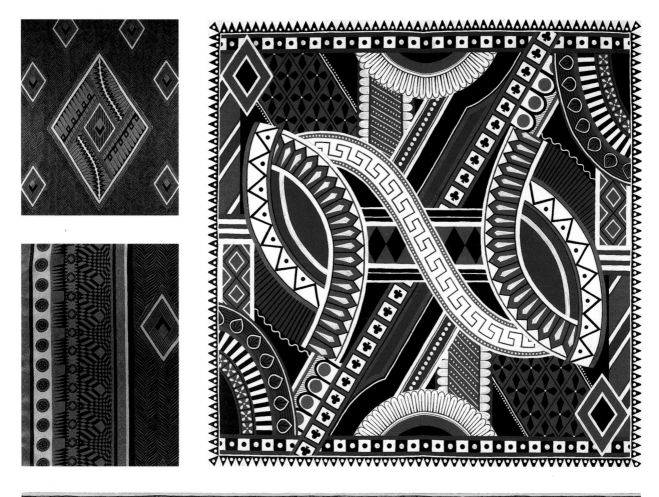

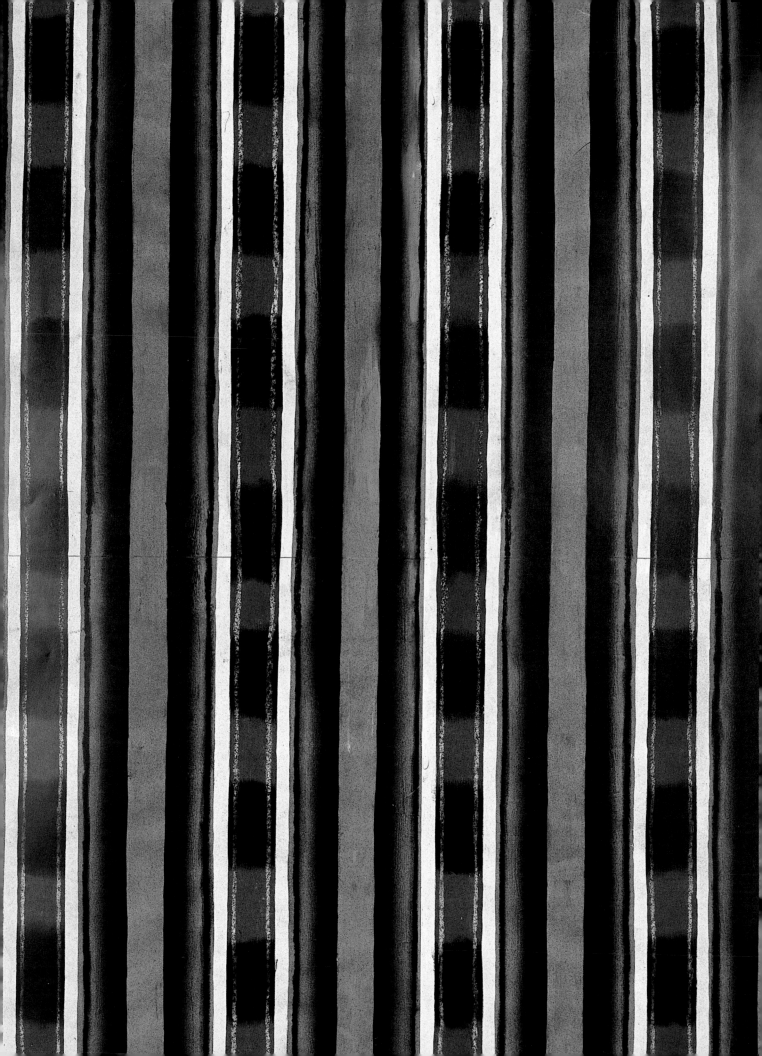

S T R I P E S

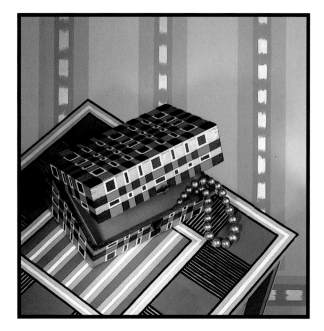

The stripe is the simplest of geometric forms and can hardly
be avoided in decorative painting. It gives a feeling of stability to a
design, both containing and structuring it. It is the starting point for
many more elaborate patterns incorporating fine lines, fat lines,
grids, checkerboards, diagonals, squares, and rectangles. It can
impart either jolliness or elegance, depending on its color and width.
To use the stripe as a decorative feature is simply a matter of being
able to create a straight line. Stripes and lines creep into almost
all of my designs and I would be lost without them.

MATERIALS

Wooden table

Primer

*Flat latex paint:
pale gray, mid-gray, dark
gray, black, white*

*Masking tape,
2.5cm (1in) wide*

*Matt (low-gloss) interior
varnish*

TOOLS

*Decorator's brush,
2.5cm (1in) wide*

*Flat artist's brush,
2.5cm (1in) wide*

Pencil and eraser

Ruler or set square

*Round artist's brushes,
medium and fine*

When faced with the decoration of a rectangular table, stripes and squares are an obvious choice as they will fit readily into the shape of the table. The only disadvantage is that quite a lot of measurement and calculation is required. Such a straightforward style of design requires a degree of regularity if it is to work, whereas a looser motif will allow a more random arrangement. Any rectangular table could be used for this project. The one shown here is small, but a larger table will do: to adjust the design either scale it up or keep the pattern the same size and simply extend it. The basis of this pattern is created very quickly, but the detail is more tricky as there are a lot of fine lines to paint. You could leave these out, but I feel that this detail adds to the charm of the design, even if the lines are wobbly.

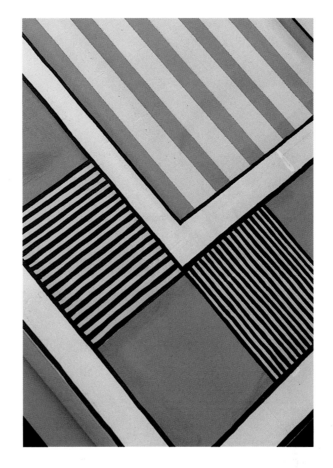

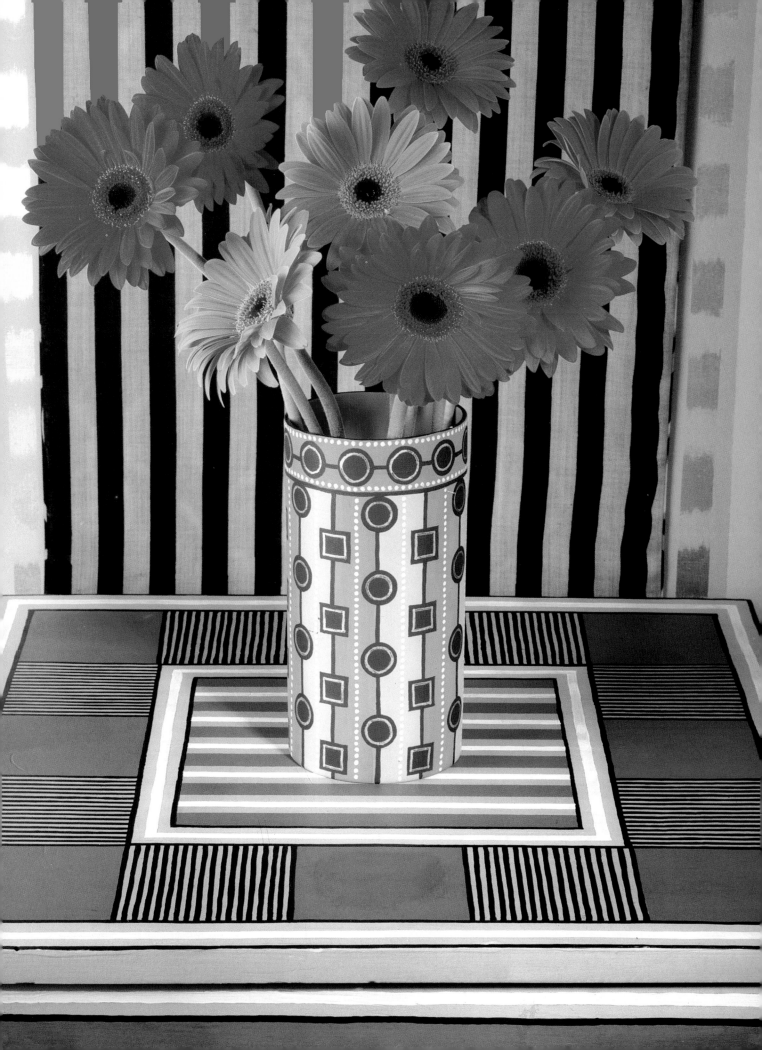

Prepare the table if necessary by cleaning, sanding, and priming it, then paint it all over in pale gray, using the decorator's brush. Next, draw out the design using quite heavy lines as they will need to show through a coat of paint. Mark a 2.5cm (1in) wide border around the edge and mask it out with tape. Divide the remaining table edge by five. Mark these divisions and form a border this width around the table, then use the marks to divide the border into sixteen equal squares. Now draw a 2.5cm (1in) wide border inside this one and mask it out.

The square left in the middle will be painted in 2.5cm (1in) stripes with the help of masking tape. Start with the middle stripe; find the halfway point of the square and mark 1.25cm (½in) on each side. Draw the rest of the stripes outward from this one. The two outer stripes may not be the full width but they will be the same size, thus maintaining the symmetry. Paint

the whole tabletop with the mid-gray latex paint, using the flat artist's brush. The heavy lines underneath should show through faintly but all the dirty marks and calculations will be obliterated. With the original tape still in position, mask out the stripes in the center, leaving the outer stripes to be painted and masking every other one. Do the same with the outer border, leaving the corner squares to be painted. Paint these areas dark gray and remove the tape when dry.

Using your ruler or set square, mark lines about 5mm (³⁄₁₆in) apart on the mid-gray squares. Paint these as narrow stripes with the fine brush and black latex. Also paint black edges to both the pale-gray borders. When these are dry, use the medium brush to paint a narrow white stripe down the middle of each 2.5cm (1in) stripe. Decorate the legs and side panels of the table to match the top. Leave to dry and then varnish, applying several coats to the top.

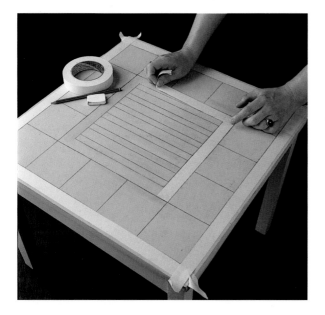

1. Draw the design and apply masking tape. Use scissors to get square corners. Stick a square-cut end of tape to fit in one corner, then tear the other end off just short of the next corner. Cut the end of the next piece and repeat, on each side.

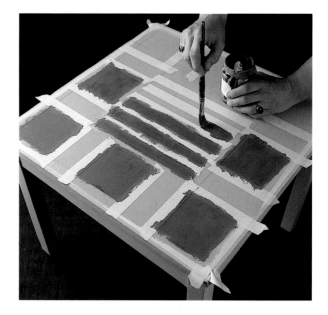

2. Stick the masking tape down on the outside of each square to be painted, following the lines showing through the paint. Apply the tape to the central stripes, making sure that the first and last stripes are both dark gray to contrast with the border.

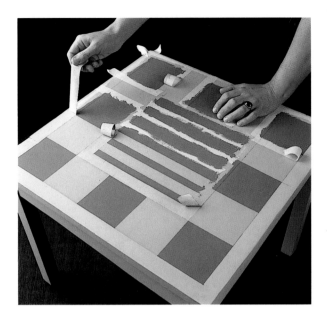

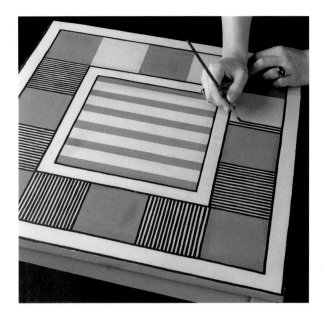

3. *The original masking tape is left in position while the dark gray is painted and then all of the tape is removed at the same time, exposing a three-color pattern. Touch up any areas where the paint has "bled" or has been picked up by the tape.*

4. *Unfortunately, it is not possible to paint lines using a ruler, as the paint tends to bleed underneath it and smudge when it is moved. Instead, follow the pencil lines as closely as you can using a fine brush and slightly diluted paint.*

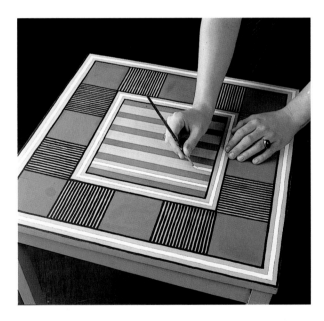

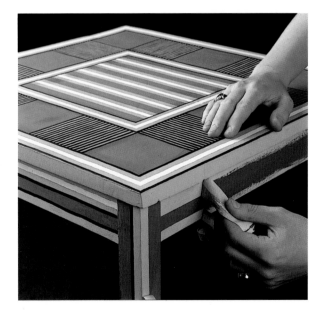

5. *Paint in the narrow white stripes by eye, or mark their position using a ruler and follow that line. Try to start and finish these stripes with a squared-off end; if you find this difficult, stick down a piece of masking tape to paint over.*

6. *The legs and side panels of the table are painted using masking tape to create the broad stripes, which are then picked out with black edges. A white stripe is painted around the side panels but not on the legs as they are too slender.*

JEWEL BOX

MATERIALS

Wooden box

Primer

*Flat latex paint:
pale gray, bright orange,
mid-gray, black*

Black metal paint

*Masking tape,
2.5cm (1in) wide and
1.25cm (½in) wide*

Gold paint

*Low-gloss (matt) interior
varnish*

This project demonstrates how to use stripes to achieve an altogether different effect. The masking tape is applied in stripes first in one direction and then in the other, wrapping around the box like ribbons around a package. Once the gold and black squares are painted in, the appearance is more checkered than striped. The box used here was old and rather rough but still ended up looking like a precious jewel box, especially once the inside was painted bright orange. You could use any box that you come across. Prepare it well and prime it if the wood is bare, so that the masking tape will not pull the paint off. Paint hinges or clasps in black metal paint and choose any bright color for the inside. If your box is radically different in size you will have to adjust the arrangement of the tape. As long as you follow the basic principles, the results should be similar.

TOOLS

*Decorator's brush,
2.5cm (1in) wide*

*Round artist's brushes,
medium and fine*

Pencil and eraser

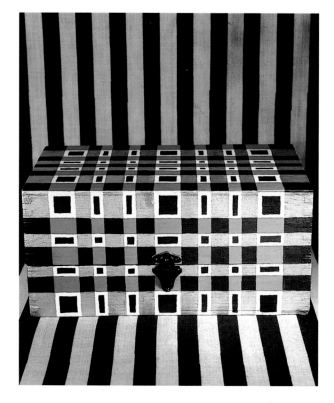

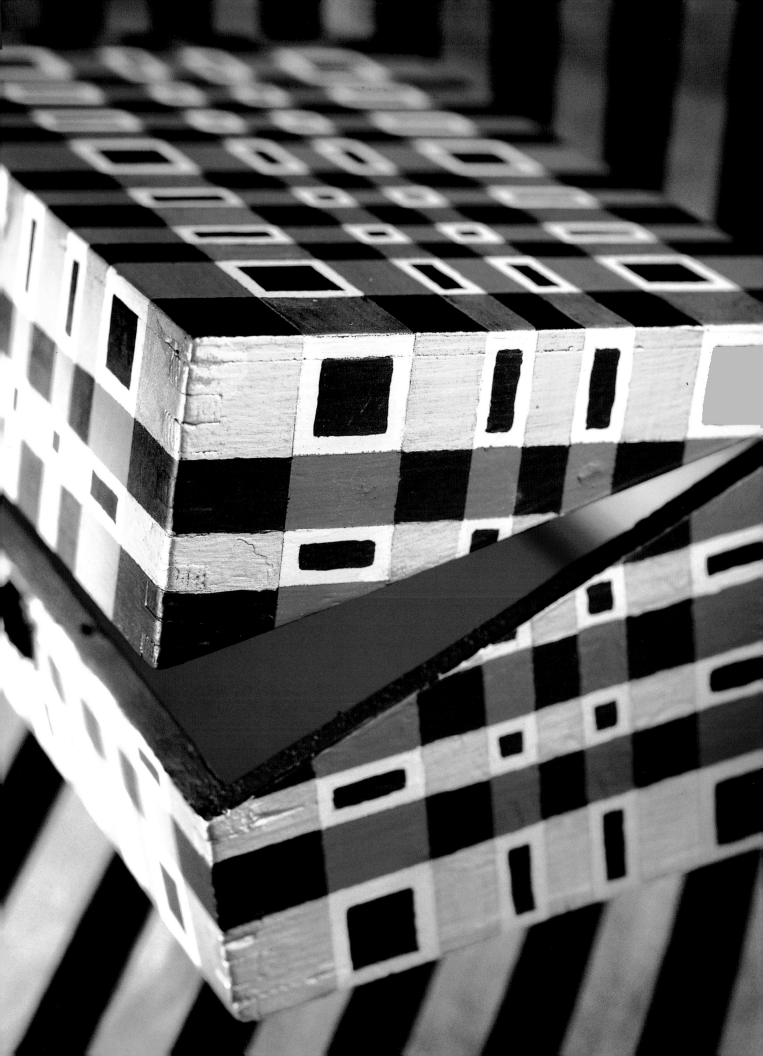

jewel box

Clean and prime the box and paint the outside all over with two coats of pale gray. Paint any metal fittings visible with the black metal paint, using the fine brush. Paint the inside with two coats of bright orange, leaving the finishing of the edges until later. Use strips of masking tape to mask out horizontal stripes around the sides of the box and lengthwise stripes along the top. I have used two strips of the wider tape on the outer edges and two strips of the narrower tape between them, equally spaced. On the top, the outer strips are positioned 2.5cm (1in) in from the edge, so the dark and light stripes will alternate. Paint with the mid-gray latex paint and allow to dry. Remove the masking tape and discard it.

Now apply more masking tape, laying it in a vertical direction up the front, over the top, and down the back of the box. Two lengths of the wider tape are stuck 2.5cm (1in) from each end, with another in the middle. In between these are lengths of the narrower tape, two on each side. At each end of the box, apply the tape vertically, following the pattern left by the tape you removed, leaving the ends free. Paint all the gaps between the tape with black.

When the tape is removed you will see two sets of stripes, one crossing over the other. In the pale gray spaces left, mark out smaller rectangles inside and paint these with the black latex paint, using the fine brush. You will need a steady hand to do both this and the next stage of painting. The gold squares are painted at every point where the black crosses over the pale gray; you can draw these intersections in first if it will help, otherwise paint them in freehand. When this is done, all that remains to be done is to neaten the edge between the outside pattern and the orange inside with a black line. Touch up any other mistakes and then finish with a coat or two of varnish.

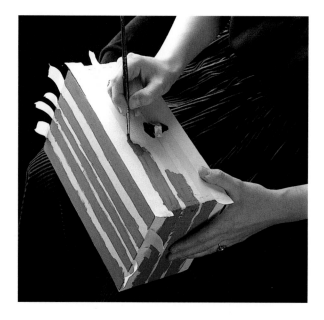

1. *Wrap the masking tape all around the edge of the box, as shown. Leave the ends of the tape on the top free and do not wrap them around. Paint with the mid-gray paint, changing to a fine brush when you come to paint around the latch.*

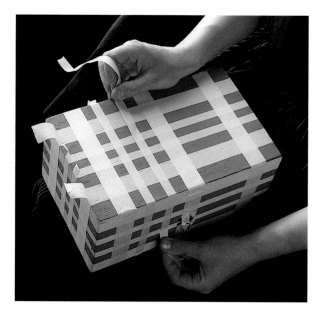

2. *Remove the tape carefully, touching up the edges if there has been any seepage underneath. This time, wrap the tape all around in the opposite direction. The lines of tape at each end should follow on from the horizontal lines on the top.*

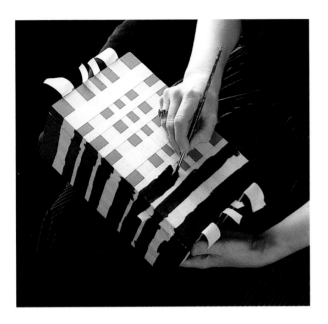

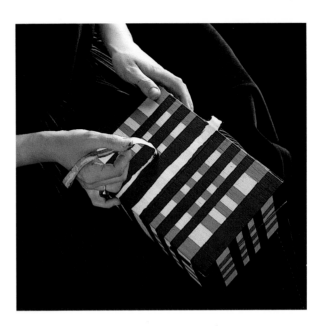

3. *Paint the black stripes in, one side at a time, allowing each side to dry as you go. When you come to each end of the top, be careful not to let paint seep down behind the masking tape where the ends are hanging loose.*

4. *Now remove these pieces of tape. Taking the tape away can be worrying as there is always the chance that some of the paint will come off too. Although this is a nuisance it is not a disaster as it can be retouched quite effectively.*

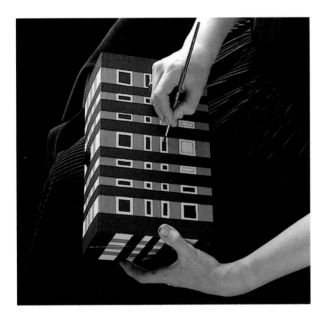

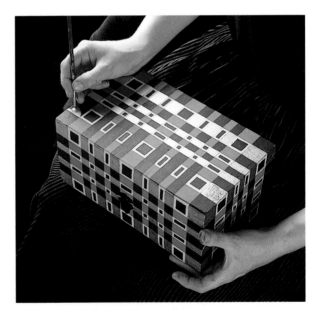

5. *Draw rectangles inside the pale-gray spaces, leaving a border 3mm (⅛in) thick. Fill these in with black, trying to keep the corners sharp. Wash your brush frequently to keep a point on it and dilute the paint a little if it does not flow freely.*

6. *The gold squares are painted at the intersections between black and pale gray, so they follow the line of masking tape you applied first. Stir the gold well, as it separates out very easily. If the black is not completely covered, apply a second coat.*

PATTERNED WALLS

MATERIALS

*Flat latex paint: pale gray,
mid-gray, dark gray*

*Masking tape, 2.5cm (1in)
and 1.25cm (½in) wide
(several rolls, depending
on size of wall)*

Gold paint

When I first painted a wall with stripes I was teased mercilessly. Why on earth take all that trouble when I could buy striped wallpaper? The fact was, and is, that there is hardly ever a paper with the color or width of stripes you want, so the only solution is to paint the walls exactly as you want them. Choosing the right color is a crucial element, as it can have a dramatic effect on the apparent size of a room. Colors which contrast too strongly will make the room appear small. That is fine if it is what you are looking for, but for this project I have chosen some rather elegant grays which do not close in on you. The stripes finish in a narrow frieze midway down the wall, but could continue to the floor. The final gold detail adds a little excitement to an otherwise rather somber-looking wall. If you prefer, you can leave it out, or paint it in a paler shade of gray.

TOOLS

*Decorator's brushes,
10cm (4in) and
5cm (2in) wide*

Ruler or tape measure

Pencil and eraser

*Flat artist's brush,
2.5cm (1in) wide*

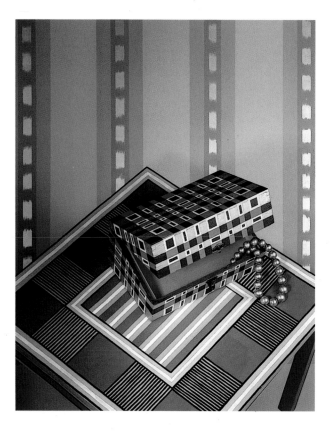

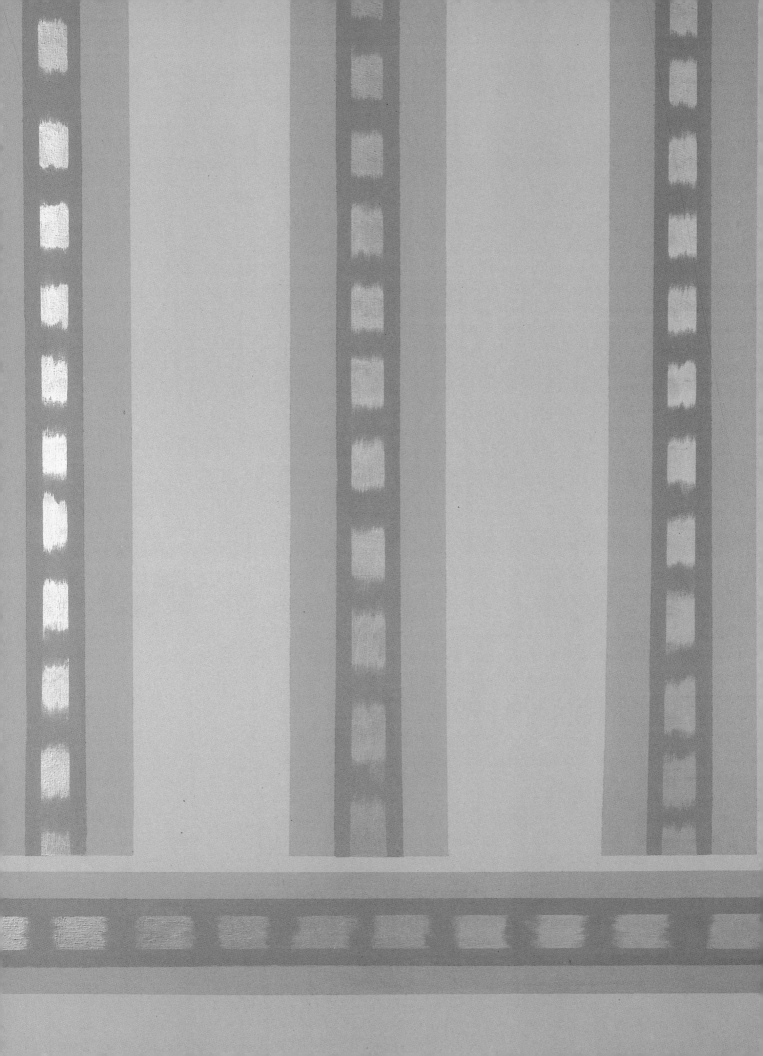

Paint the whole wall with two coats of pale-gray latex paint. If you are making a frieze as well as painting vertical stripes, mark this out at a width of 9cm (3½in) midway between ceiling and floor. Apply one strip of the narrow masking tape along each outer edge of this horizontal stripe.

To mark out the stripes you will probably need to make some adjustments to their widths first. The stripes here are 12cm (4¾in) apart. When you measure your walls you may well find that you can not divide by this measurement exactly. If so, you will have to make the stripes slightly wider or narrower to avoid ending up with a half stripe in a corner. The stripe size on different walls in a room may vary by up to 2.5cm (1in) while still maintaining an illusion of uniformity. Start from a natural break, like a door or window, and mark off the stripe widths at both top and bottom. Mask out the stripes using the wider masking tape and joining the marks. Put the tape on the outside of

the stripe to be painted; it will be one strip to the left of a mark, one strip to the right, and so on. Stand back frequently to check that it looks right.

Paint the mid-gray onto the stripes and the frieze. When it is dry, remove the tape, and apply more tape over each painted stripe to mask out a central strip 5cm (2in) wide. For economy you can use the same tape again, marking the central strip as you go and applying the tape taken from the next stripe along. Paint the dark gray onto the areas between the tape using the 5cm (2in) brush. Remove the tape when dry. Using the narrow tape, mask out the areas to be painted gold. This time butt the edges of the tape up against each inside edge of the 5cm (2in) stripe, which should leave a gap of about 2.5cm (1in). To apply the gold, use the artist's brush. Paint the gold in patches about 5cm (2in) long and 2.5cm (1in) apart, leaving feathery brush-strokes at each end. When dry, remove the tape and repair any mistakes or masking-tape damage.

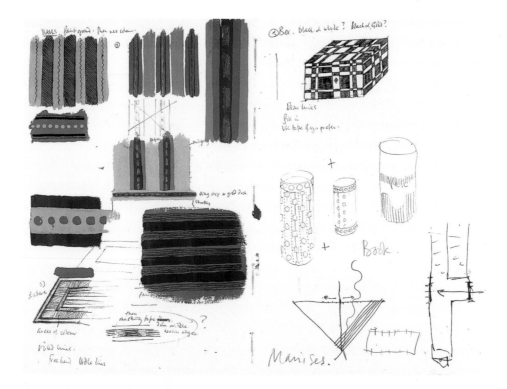

A page of my sketchbook showing patterned wall details.

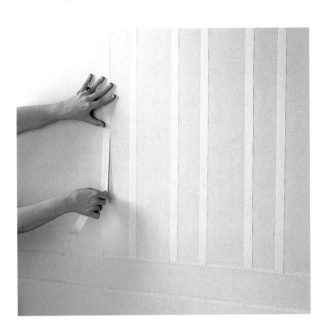

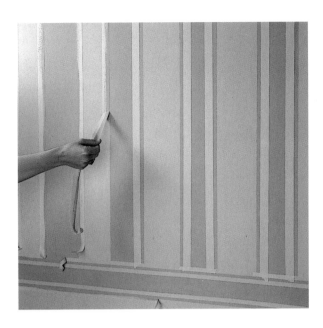

1. *Apply the masking tape to the wall, matching top and bottom marks. Stick it down firmly but do not pull it too tight or it will stretch and then bow out. To remember which stripe will be the painted one, draw arrows on the tape as you go.*

2. *Remove the tape carefully as it might take some paint with it, especially if it has been left a few days. Mark 5cm (2in) stripes in the middle of the painted stripes and apply the tape as before.*

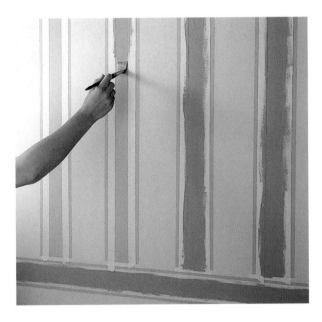

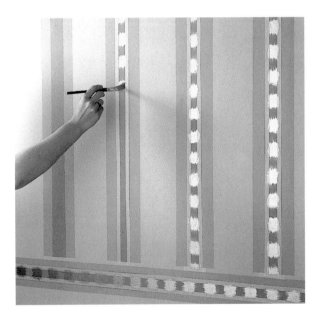

3. *Paint on the third color in the narrower stripes. Take care to fill in the stripes thoroughly but not to overlap the edges of the tape; it is easy to become slapdash when relying on masking tape to keep the edges neat.*

4. *Painting the gold might require a little practice so start in a dark corner that will not be very noticeable. The spacing is really up to you and does not need to be measured out first as this part of the design should be random.*

C I R C L E S

The circle is probably the most common decorative motif
and is certainly one of the simplest to use. It is an elemental
and universal form whether it is the tiniest dot or the most
elaborate medallion. There is always something circular
to draw around and the pure symmetry of the form makes it
a delight. Try different sizes and arrangements, using
both line and solid color. A simple all-over spot
is a favorite pattern for textiles while more complex
arrangements can be made in infinite variety.

PICTURE FRAME

Unfinished wooden frame

Primer

Flat latex paint:
mid-gray, pale yellow,
blue-gray, charcoal gray,
salmon pink, pale gray

Masking tape,
1.25cm (½in) wide
(optional)

Low-gloss (matt) interior
varnish

I experimented in my sketchbook for some time to find a design that would go with this nineteenth-century fashion plate. I felt that the picture required a feminine delicacy and lightness of touch, which is why I settled for this small-scale, dotty design. If you are using this design to frame a particular picture, make sure that the style and color will complement the image you will be framing. Alternatively, you might decide to decorate a mirror or photo frame. For the circles here I drew around a film container lid, but if you are adapting the scale of the project you will need to make yourself a template. If you decide to adapt the design to suit a picture of your own, experiment with scale and color, as it is always best to make your mistakes on paper first. The measurements in this project are based on a frame with a 9.5cm (3¾in) wide border. If you use a different size remember to adapt the measurements accordingly.

Decorator's brush,
2.5cm (1in) wide

Ruler or set square

Pencil and eraser

Lid or template to draw
around

Flat artist's brush,
2.5cm (1in) wide

Round artist's brushes,
medium and fine

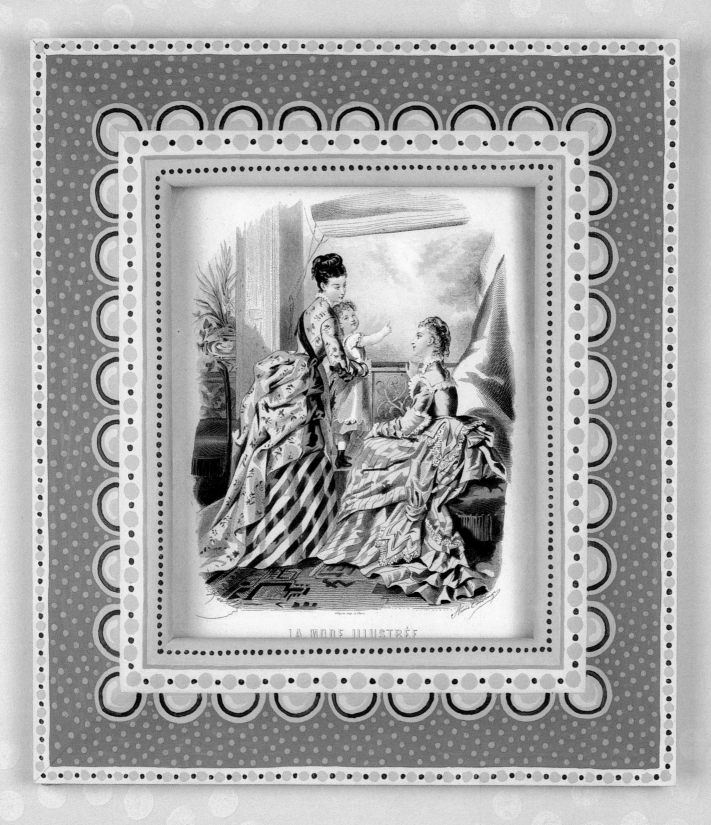

LA MODE ILLUSTRÉE

First prime the frame using the decorator's brush. Allow to dry, then measure and mark out the borders in pencil; on all four sides, draw a line 1cm (⅜in) from the outside edge of the frame for the outer border, and draw two more lines 1.5cm (⅝in) and 3cm (1¼in) from the inside, for the inner border. Next, paint in the mid-gray background color and yellow borders (using tape to mask out the different colors if necessary – see Square Table project, page 48).

To draw the semi-circles, use a small lid, such as the film canister lid I use here, as a template or cut one from thin card. Draw each corner circle, positioning the lid by eye over the inner yellow border. Measure the distance on each side between corner circles and work out exactly how many circles will fit into the space. If they do not fit exactly, calculate the space needed between each one and mark out their positions before drawing them all in.

Using the artist's brush, paint the area outside these pencil lines as far as the outer border, using the blue-gray. The gray spots on the yellow borders can now be added. Judge their spacing by eye or use a ruler to mark their position beforehand. Next, use the charcoal gray and the fine brush to paint little dots between each of these spots. Using the same color, make a line of dots along the very inside edge of the frame, and paint dark borders inside each of the semi-circles. Use the salmon pink to brighten it all with a fine line around the inner yellow border and a random scattering of dots on the blue-gray area. For the finishing touch, use pale gray to highlight each of the semi-circles: practice painting a freehand "comma" on a spare piece of paper until you are confident with the technique, then apply it to the frame with a painterly flourish. Clean off any smudges and pencil marks with the eraser and apply low-gloss (matt) varnish to seal.

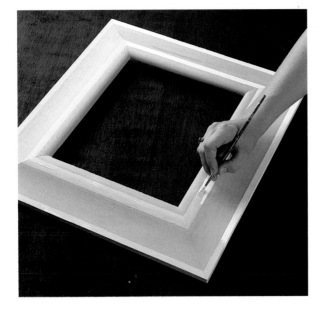

1. Painting the yellow borders. If your hand is not very steady, you could mask out these stripes using narrow tape. Paint the mid-gray area and remove the tape, then either paint in the yellow freehand or repeat the process with the masking tape.

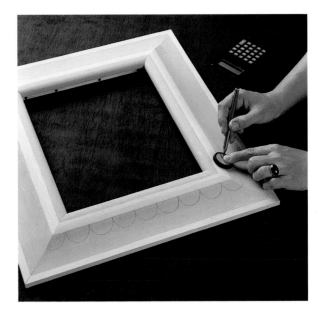

2. Drawing around the film canister lid. The line on this lid serves as a useful guide. If you are making a template, fold it in half to find the diameter and place this line along the edge of the inner yellow border to draw the semi-circles.

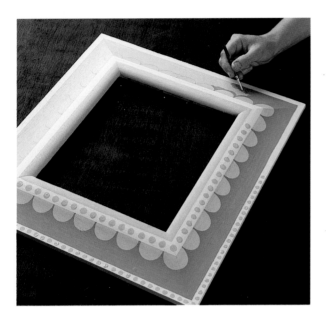

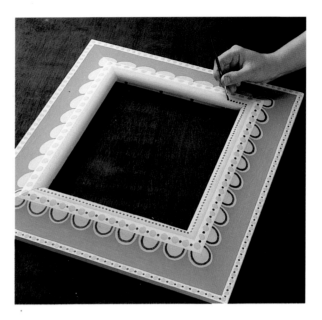

3. *Painting the blue-gray background and the gray spots. The paler color painted first serves as an undercoat. Although you are painting a large area of background color, it is generally best to paint dark over light where possible.*

4. *Adding the charcoal-gray lines and dots. The line may meander a bit, but if you prefer it not to, you could rule a light pencil line to follow. After the paint is thoroughly dry, remove the pencil line with a clean eraser before varnishing.*

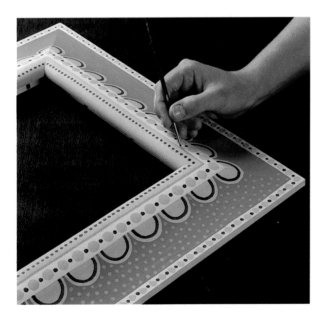

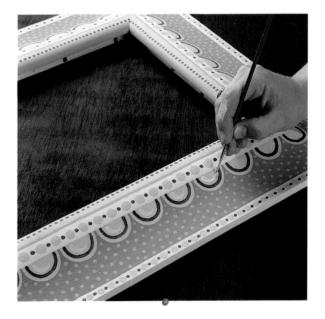

5. *Use a well-loaded fine brush to create the dots and try to work along the edges first, filling in the middle dots afterward. When painting a straight line, find yourself a comfortable position and angle of brush to help prevent wobbling.*

6. *A quick "comma" of pale gray highlights the semi-circles. To achieve a free brushstroke, practice this a few times first. After the paint has dried, you can wash off any marks with a sponge before applying at least one coat of low-gloss (matt) varnish.*

TOOLS

Decorator's brush,
5cm (2in) wide

Templates

Ruler

Pencil and eraser

Flat artist's brush,
2.5cm (1in) wide

Round artist's brushes,
medium and fine

Stencil brush

MATERIALS

Wooden door

Wooden door knob

Primer

Flat latex paint:
pale yellow, dusty orange,
gray, charcoal gray,
pale green, blue-gray

Masking tape (optional)

Low-gloss (matt) interior
varnish

Decorated doors are not very common except on the occasional closet or armoire. However, they do have a place, especially where a room is otherwise plain. A plain tiled bathroom might need a dash of color, for example, or you could liven up a dark hallway. The structure of this door lends itself to decoration, suggesting the arrangement of a pattern in panels and grids, but if you have a flat door you could draw on your own panels to achieve the same effect. The inspiration for the pattern I have used here owes its origin more to ancient Greek vases than to the bull's-eye motif. The Greeks were fond of using this design at one period, and I believe they had some sort of paint-dispensing compass to achieve it. I have not been able to find such a thing, so have used a more painstaking method. If you do not want to paint so many circles then you could miss out every second one, for a rather thinner effect.

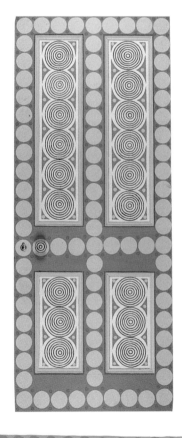

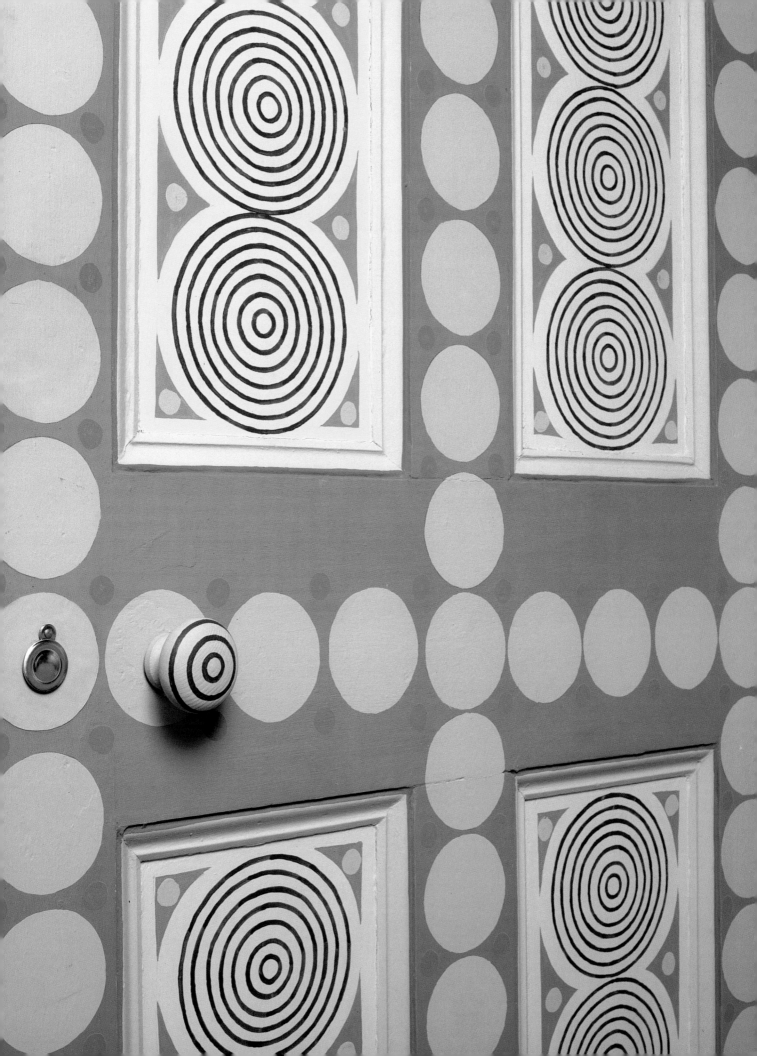

If the door is easy to take off its hinges, then remove it and lay it down on a table so that you can work in comfort. If it is new or stripped, prime it first, then paint the whole door with two coats of pale yellow latex. Paint the solid areas surrounding the panels orange and the moldings gray. You may need to add additional coats if the paint does not cover well. Next, prepare to draw the design, adjusting the templates by the required amount to fit the size of your door. Then measure the panels to work out the necessary spacing and mark where each circle should go.

To draw the concentric circles, either make a series of separate templates or cut the same one down as you go. Position each template inside the next, leaving an equal gap all around. Draw curved triangles in the background space left by the circles (known as the interstices.) Start painting the concentric circles in charcoal gray. You will find that it is easiest to paint the top half of all of one "bull's-eye", working from the outside inward, and then complete the bottom half from the inside outward. Paint the interstices in orange and the smaller circles in green.

To paint the spots, it is best to use a stencil brush. The bristles of your brush will probably be too long to make the right size of circle, but this can be remedied by wrapping the brush tightly with masking tape about 6mm (¼in) from the end. Now dip it into some paint poured into the lid of the can and scrape off any excess. To get a good circle, swirl the brush around as you apply it to the surface. Practice this a few times until you get the hang of it, then paint the spots in, as shown, in green and blue-gray. The final touches are painting the blue-gray lines to emphasize the moldings and decorating a wooden doorknob to match. Apply several coats of varnish to the door as protection against the inevitable wear and tear it will encounter.

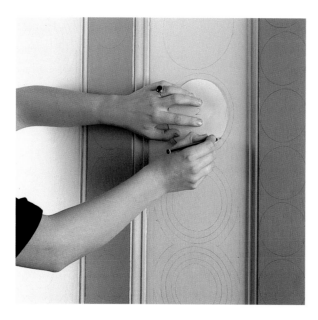

1. *Drawing around the templates. Either use separate templates for each size of circle, or mark out all the largest circles first, then cut the template down and mark all the next size. Continue to cut the template down as you go.*

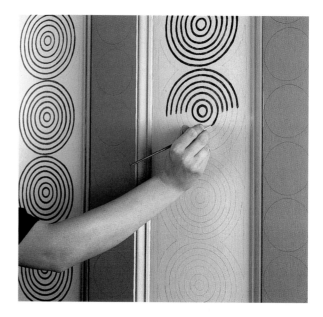

2. *You will need a fine, smooth-haired brush to paint the circles. Dilute the paint to get a good flow and do not worry if you get a few wobbles, as nobody can paint a perfect circle. This part of the door takes some time and should not be rushed.*

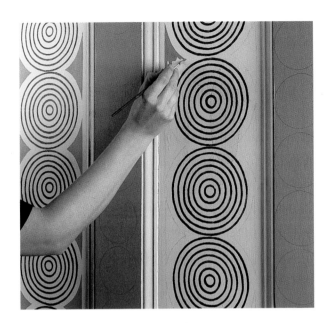

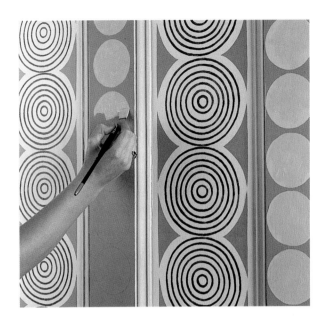

3. *Paint the spaces left around the circles orange, leaving a border of the background yellow all around the orange. This brings out the paneled structure of the door which emphasizes the circles and solidifies the pattern.*

4. *A 2.5cm (1in) artist's brush is useful for painting the smaller circles. Load it well with paint, outline the shape, and then fill in. The pale green may look a little thin as some colors cover better than others. If this bothers you, apply a second coat.*

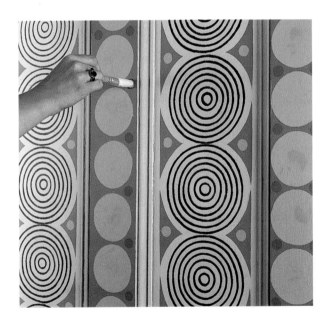

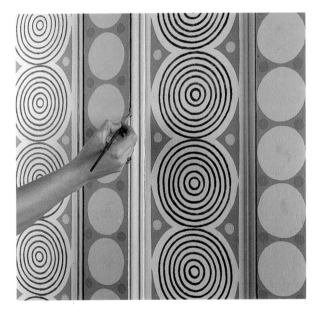

5. *Practice swirling the stencil brush on paper to get the right technique for the spots. Once the brush has turned completely you should have a near-perfect circle. The tape keeps the bristles from splaying out too far.*

6. *If you wish, you could leave these blue-gray lines off, but I think such details are worth adding; they give emphasis to the moldings and match the spots of the same color, which might otherwise look rather out of place.*

LAMP AND SHADE

MATERIALS

Vase-shaped lampbase in unglazed finish 30.5cm (12in) high

Flat latex paint: peach, salmon pink, blue-gray

Gold paint

Low-gloss (matt) interior varnish

41cm (16in) plain conical lampshade in paper

Water-based pigments or watercolors in yellow, red, and blue

The lampshade and base used here are from a stock I keep for painting. Obviously, a whole variety of bases and lampshades would be suitable for decorative painting but it is worth bearing a couple of points in mind. It is essential that the base you use does not have a shiny glaze, otherwise the paint will not stick to it permanently (unless you wish to experiment with enamel paints). Any matt finish should do – pottery, terracotta, or even wood. The lampshade should be made from paper, which may have a linen-look finish but is much easier to paint than real fabric. To paint the lampshade, it is best to use translucent colors rather than latex paint so that the shade will glow when the lamp is lit. The gold, of course, is opaque but shines with reflected light. If you like, you could buy a lampshade which is already near to the background color in order to save you one stage of the project.

TOOLS

Decorator's brush, 10cm (4in) wide

Ruler or set square

Pencil and eraser

Round artist's brushes, medium and fine

Small coin and large coin

Soup plate or similar for mixing

White paper

Template

Craft knife or scissors

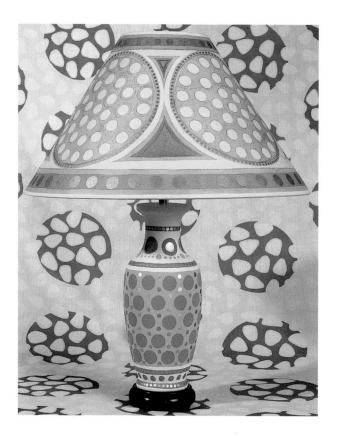

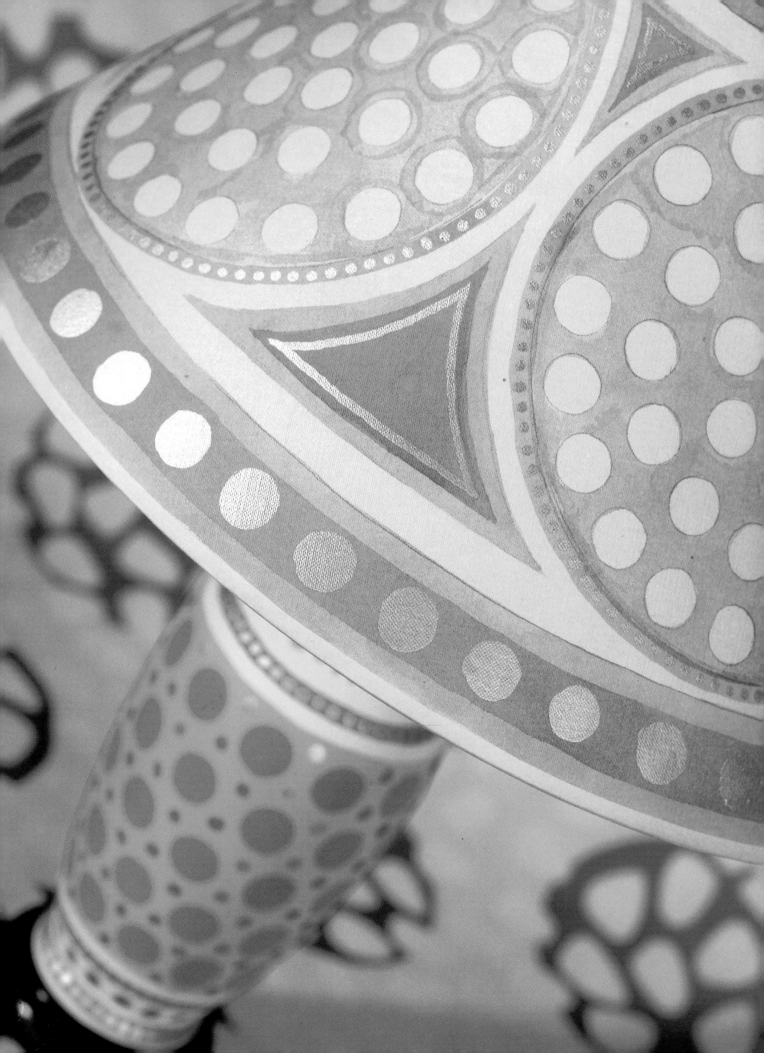

LAMPBASE

Paint the ceramic part of the lampbase in peach. Using a ruler or set square, draw five pencil lines around the top of the lamp. The first line should be 9cm (3½in) from the top edge and the others above this at intervals of 5mm (³⁄₁₆in), 5mm (³⁄₁₆in), 4.5cm (1¾in), and 5mm (³⁄₁₆in). Draw five more lines at the bottom, reversing the process. Draw the first line 6.5cm (2½in) up, with further lines 5mm (³⁄₁₆in), 5mm (³⁄₁₆in), 1cm (⅜in), and 5mm (³⁄₁₆in) below it. Paint the central area between the two innermost lines in pink. Paint the four narrow bands formed by the remaining pairs of lines in blue-gray. Using the small coin as a template, draw spots all over the pink area. Start with a row at the top, leaving at least 6mm (¼in) between the circles. Adjust to fit around the vase, erasing and trying again where necessary. Draw another row below this, staggering the spots and trying to keep them equidistant. Continue until you reach the bottom; they will get closer as the vase narrows. Using the larger coin, draw a row of bigger spots around the neck of the vase. Paint all the spots blue-gray. Paint small pink spots around the neck, under the blue-gray ones, and blue-gray spots around the bottom border. As a final step before varnishing, use gold paint to embellish the lamp, adding spots in the pink gaps left between the blue-gray spots, on top of the blue-gray spots around the top and bottom borders and in lines along the blue bands. Varnish the base when dry with low-gloss (matt) interior varnish.

LAMPSHADE

You will need to experiment to find the right color for the lampshade. Pour about half a cup of water into a dish and gradually add the red and yellow paint or pigment to it. Try out the color on white paper and allow it to dry. The shade will normally absorb rather less paint so will come out a paler color. Bearing this in mind, adjust it as necessary, adding more water or color until it is similar to, but a little darker than, the peach of the base. Remember that the color will look much stronger when freshly painted than when it is dry. Paint the shade using the decorator's brush. Hold it by the metal fitting inside and turn it steadily, covering it as quickly and smoothly as you can. Use vertical strokes, but stop short of the top and bottom as the paint has a tendency to splatter on to the inside of the shade. Finish off with horizontal strokes along the two edges and around the top and bottom rims. The paint will probably drip somewhat, so protect your floor or table. Do not worry if this base coat is uneven as the pattern on top will hide a multitude of sins. Move the shade around while the paint is still very wet, evening it out as much as possible, then leave the lampshade to dry on a piece of paper to collect the drips.

Enlarge the circular template to 18cm (7in) across. Cut it out and find the diameter by folding in half. Cut out the small circles inside the template using a sharp craft knife. Draw lines around the shade 2.5cm (1in) from the top and 4cm (1½in) from the bottom edge. Measuring along these lines starting at the seam, divide the shade into quarters, then rule between each pair of marks with a faint line. Place the diameter of the template over one of these lines, leaving an equal space top and bottom. Attach the template lightly, using masking tape, and draw around the outside of it and around the inside of the small holes. Repeat for the other three circular patterns around the shade. Draw curved triangles in the background spaces left by the circles, leaving about 1cm (⅜in) space all around. Draw a 5mm (³⁄₁₆in) border around each of the four circles.

Mix further colors as above to obtain a pink and a light blue similar to those on the base. Paint the edges of the four circles, the top and bottom borders, and the background shapes in pink. Mix a darker pink and paint the borders and triangle shapes again, leaving a narrow edge of pale pink all around. Paint the four template patterns in blue. Finish off by using gold to make little dots around the pink edges of the four circles, lines just inside the pink triangle shapes, and spots around the pink borders at the top and bottom.

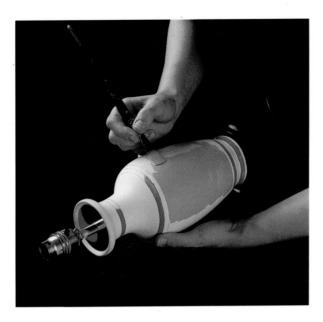

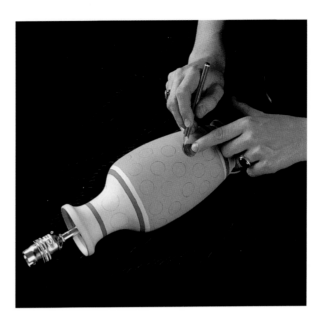

1. *Painting the base. Find a comfortable painting position so you can maneuver the lamp easily. The paint dries very quickly as it is absorbed by the base, but if necessary you can balance the lamp between base and fitting.*

2. *You may find it difficult to hold the coin and draw at the same time. If so, try sticking it in position with a small piece of reusable adhesive clay. It is quite usual to make mistakes at this stage but they are easily erased and rectified.*

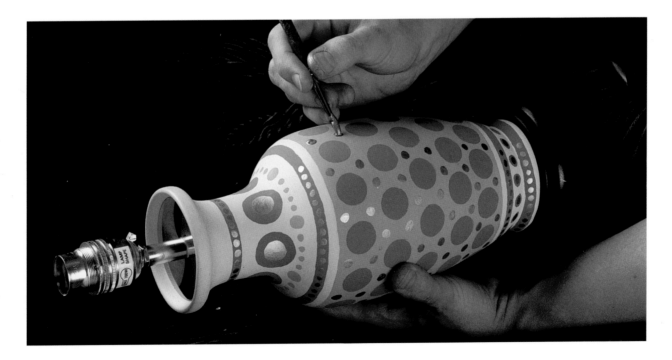

3. *With all gold paints it is important to make sure the gold is mixed well before you use it, as it has a tendency to separate. Keep a mixing brush in the pot and give it a stir now and then. Paint on the spots and feel free to embellish all you want.*

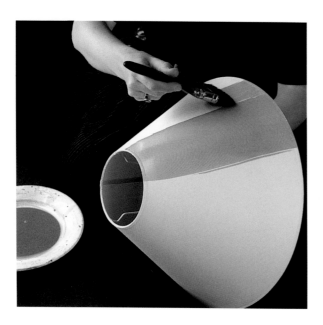

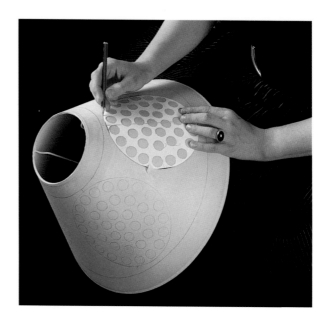

4. *Painting the lampshade. Hold it away from you so the paint does not drip on you, and paint in broad sweeps, filling in gaps and smoothing the color as you go. While it is still dripping wet, keep moving the shade to even out the paint.*

5. *Draw around the template using your diameter line to position it. Do not stick the masking tape down too firmly as it could tear the paper shade. Before moving on to the next circle, check to see if you have left a spot out; it is easily done.*

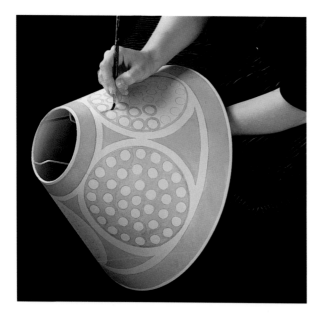

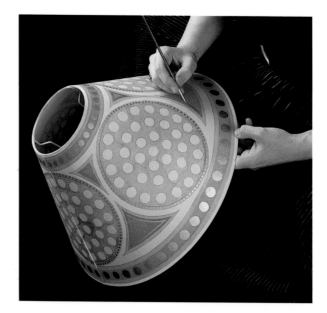

6. *Paint the template pattern in blue, starting at the edges and filling in gradually. Do not worry if it looks uneven; this is bound to happen when painting details and will hardly be noticeable when the shade is finished.*

7. *Adding the gold dots, spots, and lines. Use the coin again if you need pencil guidelines to follow, but draw lightly as dark marks cannot usually be erased completely without damaging the lampshade.*

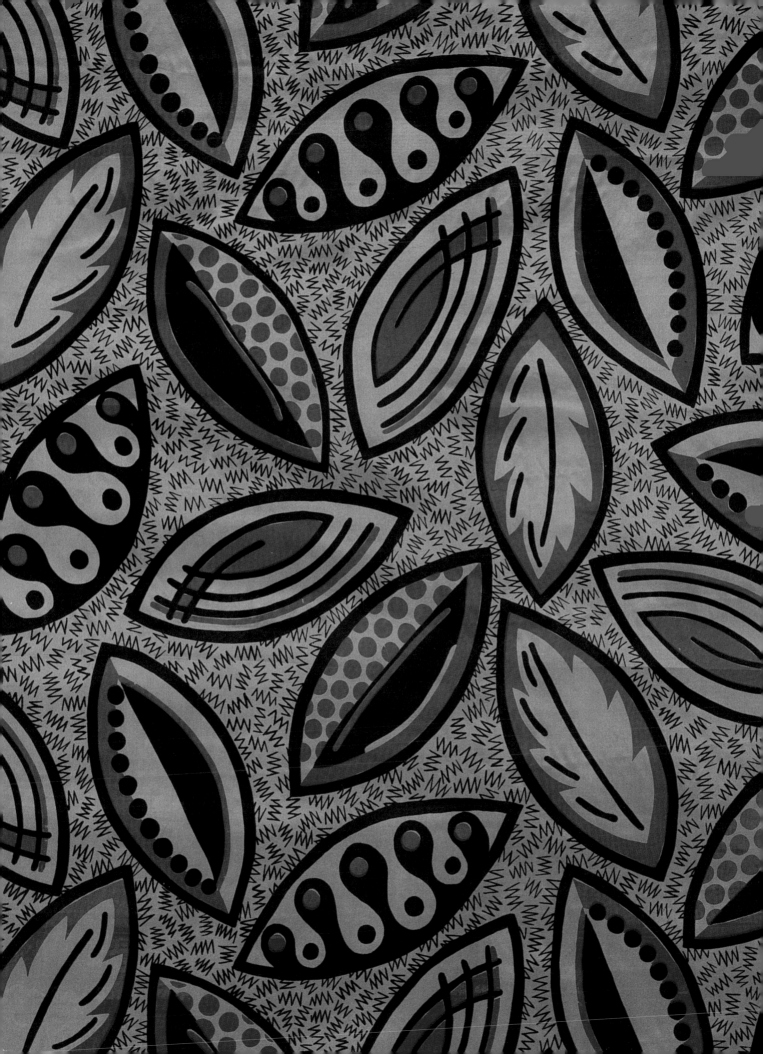

LEAVES

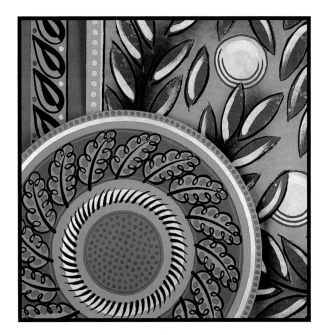

*The leaf is a wonderfully versatile pattern. It may be both
floral and geometric. Used at its most realistic it can impart an
organic lushness and has the vitality of any natural form. It can be
highly decorative, embellished with ornament, and elaborate in
design; or it can be starkly abstract, losing any relationship to the
natural world and taking on the solidity of a geometric shape.
The central stem can give a leaf a strong directional quality and a
feeling of growth. And the infinite variety of shape makes
the leaf a suitable decorative motif for any situation.*

MATERIALS

Unglazed jug or pot

Flat latex paint: yellow-green, black

Gold paint

Low-gloss (matt) interior varnish

This simple oak-leaf pattern makes use of counterpoint within the design by reversing the colors on either side of a central vertical line, representing the stem or spine of the leaf. It is often worth trying this device with any design motif to enliven what might otherwise be quite an ordinary pattern. The jug or pot must be in an unglazed or biscuit state in order for the paint to adhere. I usually come across pots to paint by chance; garden centers, thrift stores, or gift importers often have the right sort of thing. Sometimes the pottery is very rough or has a pattern stamped into it. If this is the case, it can be sanded down and smoothed out with an all-purpose filler. Ideally, any pottery that has to hold water should have a glazed interior or the water will eventually seep through. However, you can always cut down a plastic bottle or container to fit inside, creating a flower vase.

TOOLS

Template

Flat artist's brush, 2.5cm (1in) wide

Pencil and eraser

Ruler

Tape measure

Round artist's brushes, medium and fine

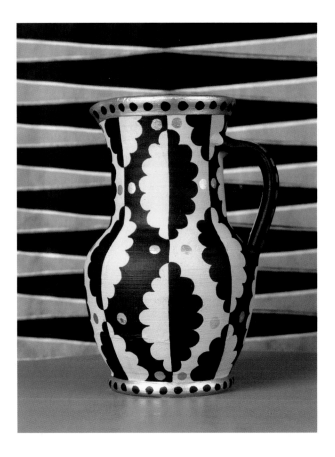

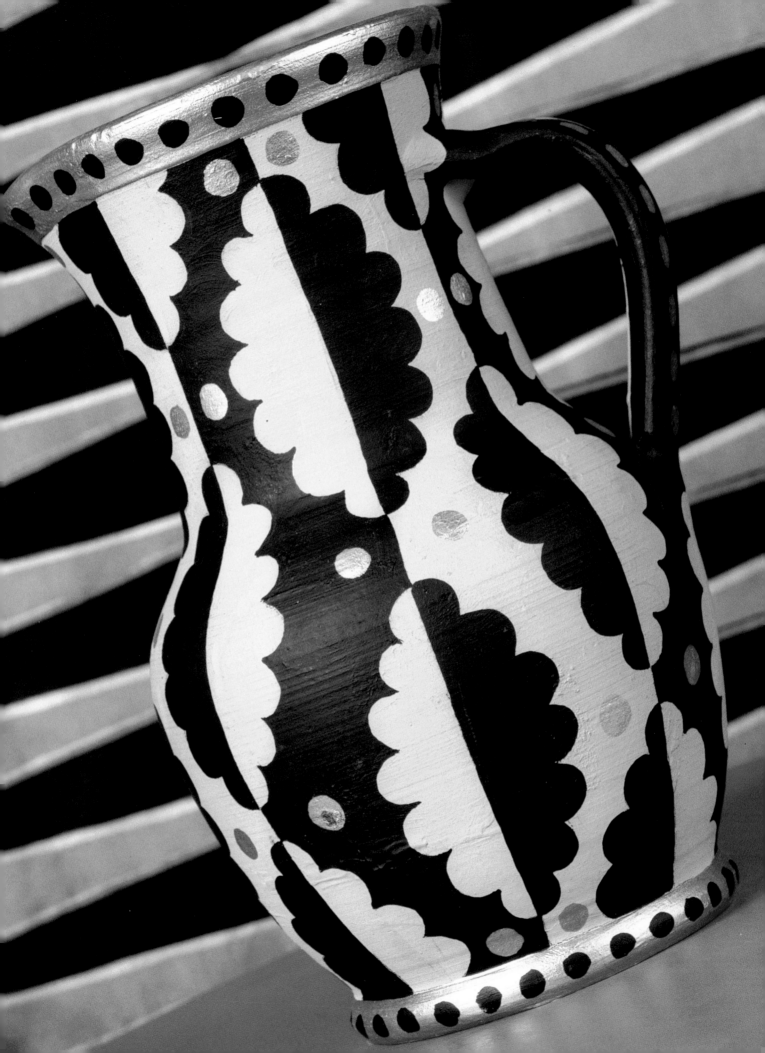

First adjust your template so that it is the right size for the jug you are using; it should be just over a third of the total height from rim to base. Make sure the pot is clean and dry before you start. Using the flat brush, paint the pot yellow-green all over, stopping in a neat line around the rim. This color will form the "positive" shape of the oakleaf when you fill in the "negative" shape with your black paint.

Draw a line around the top and bottom of the jug to create a border about 1.25cm (½in) wide. Using the ruler as a guide, draw a vertical line through the center of the handle. Measure around the rim and the base of the jug with the tape measure. Divide these lengths by eight and mark the points around the rim and base. (If you have a very slender vase you may need to make only six divisions.) Draw vertical lines between the pairs of points at top and bottom with the help of a ruler. Work out the positioning of the leaves by roughly sketching around the template a few times in different places. Adjust and erase as necessary – I sometimes erase my designs several times before they work out right. Once you are satisfied, complete the drawing on the pot. When you come to the handle, bend the template around so that it fits underneath.

Paint in the black areas using the fine brush, diluting the paint slightly if necessary to get a good flow of paint, but being careful not to thin it so much that it does not cover properly. Allow to dry. Using gold paint and the medium brush, fill in the top and bottom borders and dot with spots of gold in a regular pattern, adding a row of spots down the spine of the handle. Allow the pot to dry completely before adding the final decoration of black spots in a row along the top and bottom borders, over the gold. Rub out or retouch any mistakes you have made, then finish off with a couple of coats of low-gloss (matt) varnish.

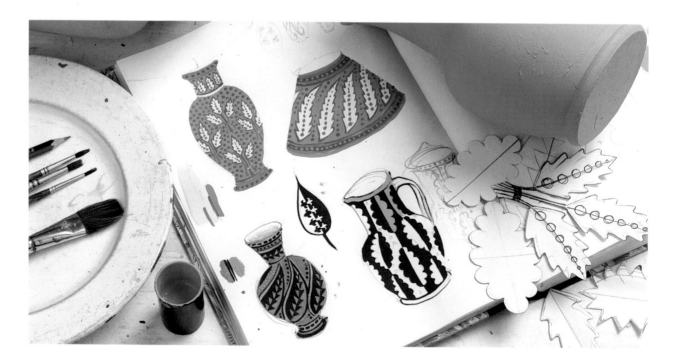

When working out how a design will fit into a particular shape, try it out first in your sketchbook, as it will save making too many mistakes later. Experiment with different colors at this stage and keep any rejected schemes as they can always be used another time.

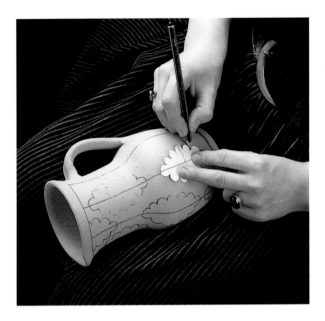

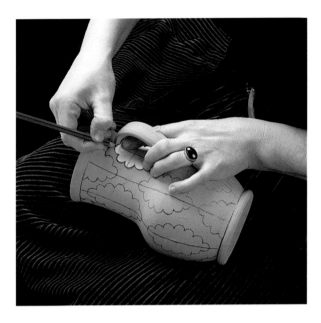

1. With the pot in a position you find comfortable, draw with a pencil around the template, holding it in place with the other hand. Match the central line of the template to the line on the pot. Do not forget you can erase any mistakes you make.

2. To deal with the awkward area under the handle, bend the template, and draw around it. If it is difficult to hold in position, stick it down with tape. The very end of the leaf shape underneath the handle can be omitted, as it will not be seen.

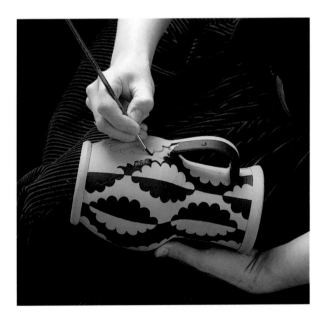

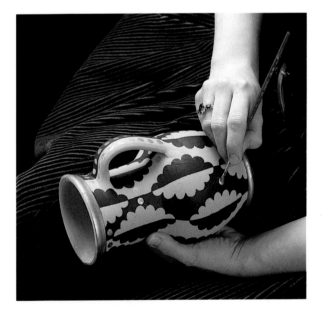

3. Using the black paint, carefully paint around the edges of the "negative" areas first with as steady a hand as possible. It is then quite easy to go back and fill in the rest of the space. Work around the pot slowly, turning it as it dries.

4. Painting the gold dots can be done quite freely using the medium brush and loading it well. The gold paint does not dry as quickly as the flat latex paint so you may need to leave one side to dry before turning it around to paint the other.

MATERIALS

Table approximately
45cm (18in) in diameter

Primer

Flat latex paint:
dark green, blue-gray,
mid-green, black

Gold paint

Matt interior varnish

It is a very satisfying task to transform a little table such as this. I have chosen to use a design with a lot of movement to it, accentuating the circle with bold brush strokes that give an appearance of motion. You could use the same design for a larger table, either by scaling the whole thing up or by changing it, keeping the narrow border but leaving a much bigger central area either monochrome or spotted. If you do not have a table with similar legs to this one, you will have to use your own inventiveness to adapt the pattern I have used. The point of such a project is not to cover up an expensive polished piece of furniture but to add value to something that was just a cheap, second-hand table or a piece of dull furniture needing a facelift. With this and other such projects you can furnish a whole house – using time, trouble, and creativity, but not much money.

TOOLS

Decorator's brush,
5cm (2in) wide

Flat artist's brush,
2.5cm (1in) wide

Pencil and eraser

Set square

Ruler

Template

Pale-colored pastel

Round artist's brushes,
medium and fine

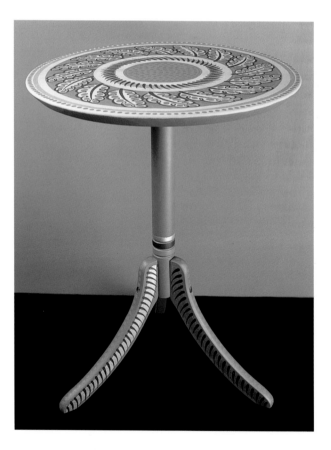

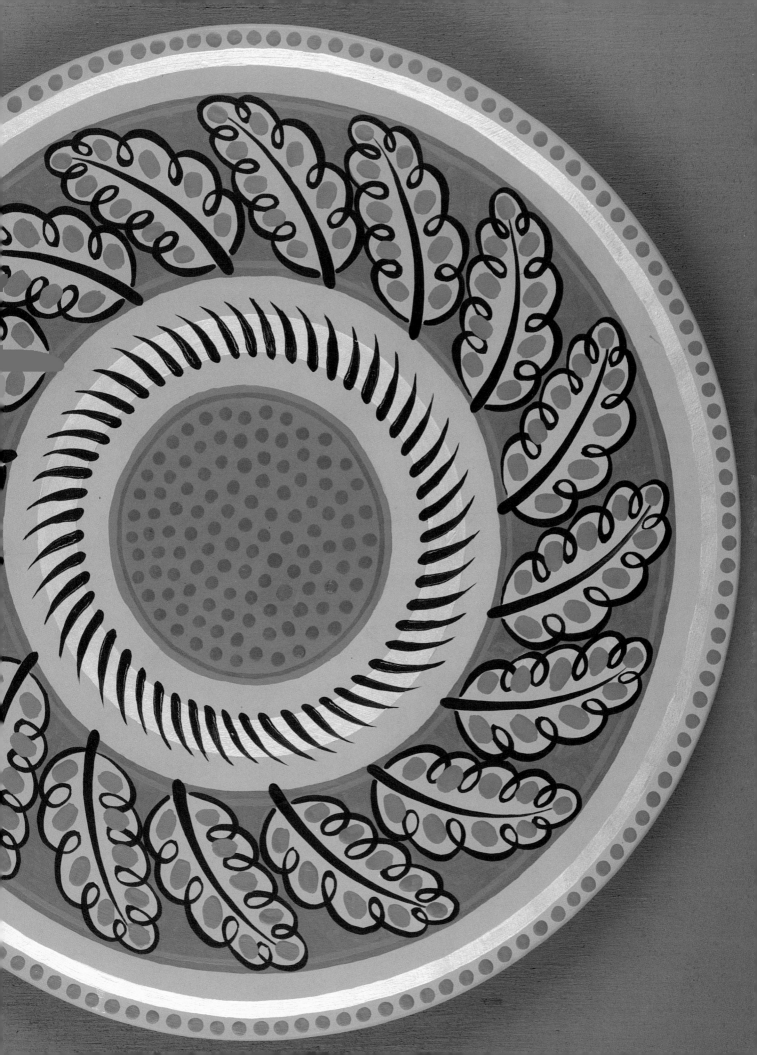

Prepare the table if necessary by cleaning and priming it. Paint the legs and the underside of the table dark green. Paint the tabletop blue-gray. To help you draw out the design, first find the center of the table and then divide the whole circle into eighths using your set square. (If you prefer, cut a paper circle the size of the table, fold it in half three times, and use this to mark all the necessary points.) Next, draw a series of circles to form the structure of the design. From the outer edge inward, the first one is 1.5cm (⅝in) from the edge, then the others are at intervals of 1.5cm (⅝ in), 8cm (3⅛in), 1.5cm (⅝in), and 1.5cm (⅝in).

Once these are drawn you can trace off the leaf shape. Adjust the size of the template if necessary and rub the back of it with the pastel. Position the leaf shape using the guidelines. Place the left-hand line on a dividing line on the table. Trace it off, using a pencil, and then move the template to the right and use the right-hand line to position it. Repeat all the way around the circle, renewing the pastel if necessary.

Paint the central circle in mid-green and the background to the leaves in dark green. Then paint the outlines and stems of the leaves in black, using a fine brush. The stems should taper toward the end and the outline should appear to be a continuous line if possible. Paint borders of mid-green around the edges of the dark-green band and a dark-green border around the inner circle. Paint a wide gold band between the pencil lines in the center of the table and a thinner one over the outer line. When these are dry, paint black dashes over the inner band, similar to the stems of the leaves. Finally, paint mid-green spots around the edge and on the leaves and fill the middle circle with dark-green spots. The legs are decorated in a similar way. Paint wide bands of gold on either side of each leg, following the curve of the woodwork. Over these add black dashes, like those on the tabletop, tapering from the top downward. When dry, apply several coats of varnish to the top to protect against wear and tear.

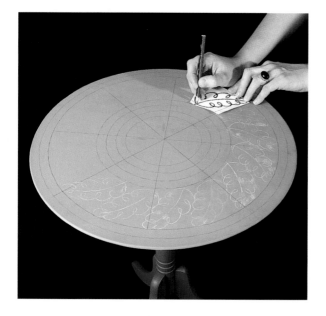

1. *Trace the leaf design onto the tabletop using a pastel pale enough to be easily visible against the background color. It may leave some smudges but they can be wiped off when you have finished painting. The guidelines make it easy to position.*

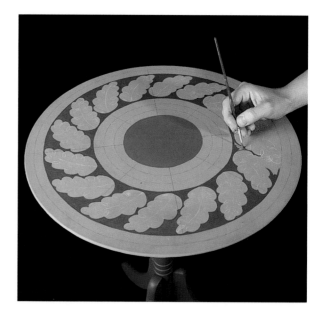

2. *Paint the background to the leaves, between the pencil lines, in dark green. Try to avoid smudging the pastel or erasing it as you go. If you find this happening, protect the drawing by using a sheet of clean paper to rest your hand on.*

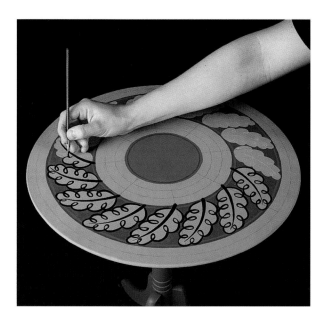

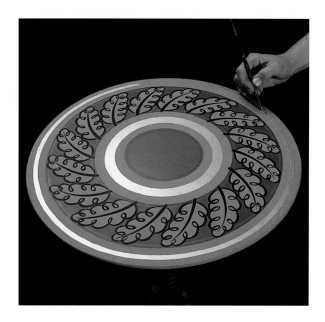

3. *Use a fine brush to paint the outlines. You may have to break the line while painting around the loops, but try to make it look continuous. Wash your brush frequently as you work to prevent it from becoming clogged up with paint.*

4. *After painting the borders of contrasting green, paint the gold bands as shown, using the wide brush for the inner band and the medium brush for the outer one. If you make a mistake, wipe the gold off quickly when still wet, or paint over it later.*

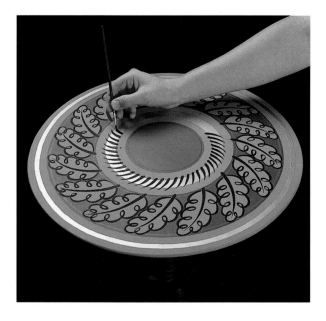

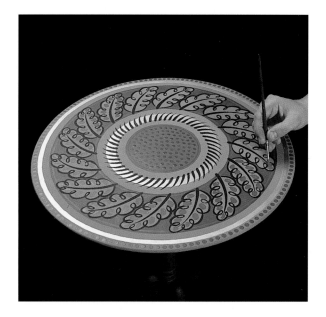

5. *The black dashes are painted in a similar fashion to the stems of the leaves, tapering toward the end and swirling outward. Draw them first if it helps you with spacing and direction. Practicing will help you to achieve spontaneity.*

6. *The spots are best applied with a medium brush, well loaded with paint. They may look like little bumps but will flatten out somewhat with drying. Wait until all the paint is thoroughly dry before rubbing out the pencil marks that still show.*

WINDOW SHADE

MATERIALS

*Window shade (preferably
with a smooth finish)*

*Flat latex paint:
pale green, dark green,
black*

Masking tape

*Dark-green water-based
spray paint*

Gold paint

Newspaper

Clear fixative spray

At first glance this might seem like a complex project
but the fact that you are painting a flat surface makes it
quite straightforward. There are many window shades on
the market but all too often they are either dull or have
very ordinary patterns on them. By painting your own
you can be sure of having something fresh and original.
The shade I used had the disadvantage of being made
from fabric, which meant that it was liable to pucker
unevenly when being painted. It flattened out in the
end but it might be wiser for you to buy a synthetic or
plastic-coated shade. If you cannot paint it *in situ*, then
try to fix it up vertically somewhere else; it will be eas-
ier to use the spray paint and it will allow you more flu-
ency of motion when painting. Bear in mind that there
are many other possible uses for a shade – to cover a
messy shelving unit, for example, or to hide a hatchway.

TOOLS

*Pale-colored chalk, or soft
pencil and eraser*

Design plan

Template

*Flat artist's brush,
2.5cm (1in) wide*

Protective face mask

Large foam-eraser sponge

Craft knife

*Round artist's brushes,
medium and fine*

*Round or flat hog-bristle
artist's brush, medium*

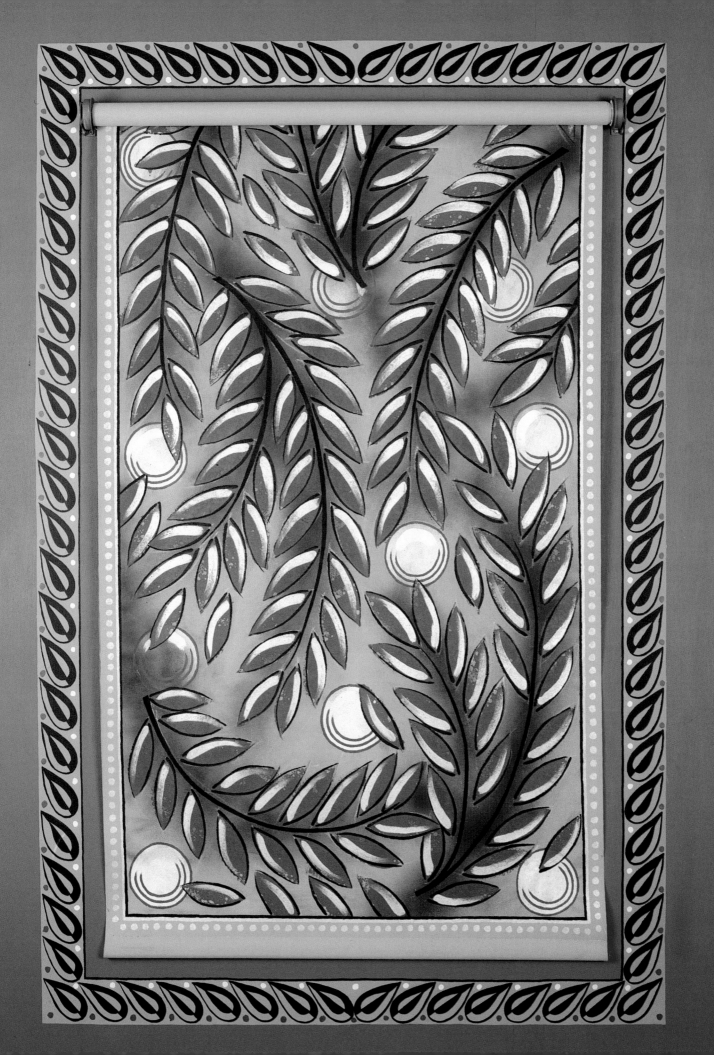

Pull the shade down to the length you will see when it is fully closed. Make a mark at the highest visible point, then roll the shade down about 10cm (4in) further. Using your chalk, draw lines 2.5cm (1in) in from the side edges and from the bottom stitching, and at a point about 2.5cm (1in) above the point where the pattern will become visible.

Enlarge the small design supplied so it will fit the size of the shade. You can do this by squaring the design up (as described on pages 40-41) or by copying it straight onto the shade using your chalk. Use the template to draw the circular fruit. Paint these on first, using the pale green. Next, mask out the edges of the shade by sticking down masking tape along the pencil lines. Then mask the whole of the surrounding area by covering it in newspaper to protect it from drifting spray paint. Wearing a protective mask, spray along the lines of the branches, to form dark-green shadows.

While this is drying you can cut your sponge into shape to use for printing. Use a foam-rubber sponge (the type used for washing cars) and draw your leaf shape onto it. With a long-bladed craft knife, cut the shape out, to the full depth of the sponge. This can now be used to "print" the paint onto the shade, similar to a potato print. Pour some paint into the paint-can lid and dip the sponge into it. Press the sponge down in position where a leaf is drawn, and repeat until all the leaves are done, replenishing the paint as necessary. Practice a few times first to make sure it works. When this is dry you can remove the paper and tape.

The next step is to paint in the lines. Outline the fruits in green and draw another two semi-circular lines within each one for shading. Use a fairly diluted black to draw in the stems, branches, and leaf outlines, starting the lines thick and tapering them off. Also paint a black line around the inner edge of the border. Finally, highlight the leaves and fruits with a dash of gold paint and finish the border with a fine gold line and some gold dots. To fix it, use a strong fixative and spray on several coats to give it a sheen.

1. *The edges here have already been taped. The design is loosely drawn in chalk and any obvious gaps are filled with a few stray leaves. For the fruit a template is used, although the right-sized can lid or something similar would do very well.*

2. *The fruit shapes are painted in with flat, pale-green flat latex paint. They are painted first, so that when overlaid with sprayed shadow and the printed leaves, they will appear to be behind the branches and will not glare too brightly.*

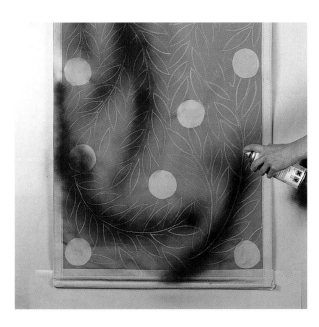

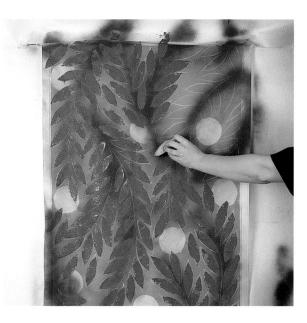

3. *The whole of the surrounding area is masked off, as spray paint gets everywhere. Shake the can well before spraying, and have a few practice shots before attempting the real thing. It may look very dark but will soon blend in as background.*

4. *This is a messy job and those who mind about green fingernails should wear rubber gloves. I often cut more than one shape from the sponge so as to have some variations and so I can throw away a sponge that has become saturated.*

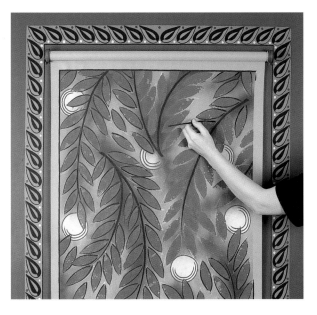

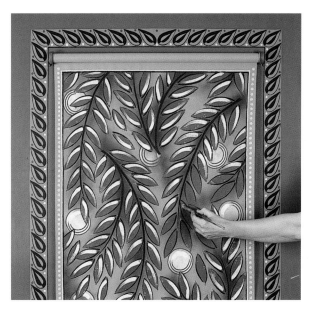

5. *The process of painting on the black lines can be laborious if your shade has a rough finish. Make sure the paint is adequately diluted but not watery. If your shade has a smooth finish this should be an easy and satisfying job.*

6. *The dashes of gold really do make a huge difference to this design, making it lively and bright despite all the dark green. Using a hog-bristle brush, start at the branch end of each leaf and let the gold thin out as you reach the other end.*

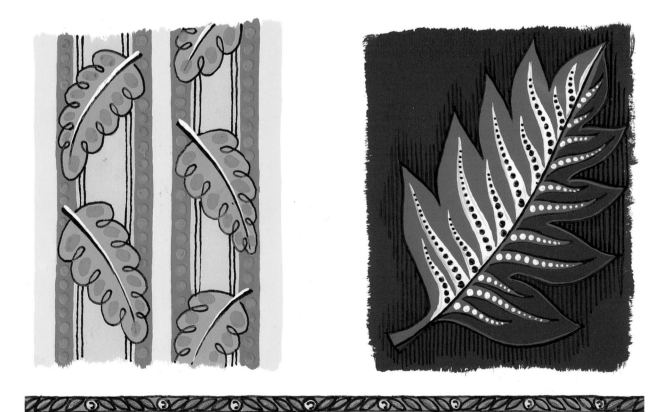

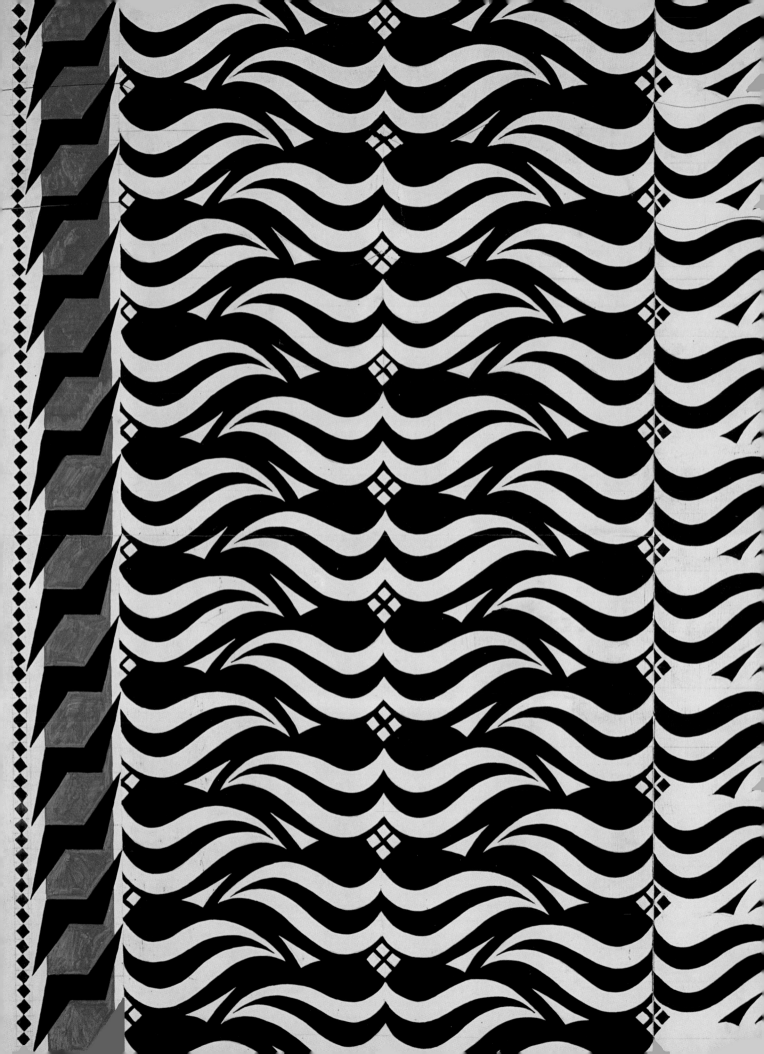

TIGER

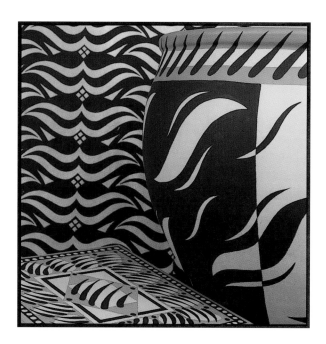

This classic pattern comes originally from Tibetan tiger rugs, but has a strong connection with Ottoman art, where it is combined with the leopard spot to form a design commonly found on sultans' kaftans. The animal quality of the pattern gives it an immediate exotic impact as well as great graphic strength and elegance. Variations on this theme have been found throughout the centuries on every kind of artefact, from carpets to furniture. The tiger pattern can easily be adapted and reworked to suit almost any use.

MATERIALS

*Hardback book,
24 x 28cm (9½ x 11in)*

*Flat latex paint:
orange, yellow ocher, black*

*Low-gloss (matt) interior
varnish*

Although there are many decorative books in the stores covered with marbled or printed papers, it is not always easy to find the one you want at the right price. You may find the perfect address book or photo album but it may not come with a binding that you like. Decorating a book cover for yourself overcomes this problem. Also, a book cover like this is ideal for a gift with a personal touch. It could be a blank book, for use as a sketchbook or scrapbook, or one with a more specific use. As usual, I use flat latex paint for this job, and varnish it afterward. The paint may crack eventually, where it is constantly being folded, but the plasticity of the paint stands the test of time pretty well. This design is a fairly loose adaptation of the tiger theme; it is the color and striped feel that tie it in. It should fit a variety of book sizes, as the center part of the pattern can be expanded or contracted. However, you may have to adjust the measurements if your book is a radically different size.

TOOLS

*Flat artist's brush,
2.5cm (1in) wide*

Pencil and eraser

Ruler or set square

Template

*Round artist's brush,
medium*

Stencil (optional)

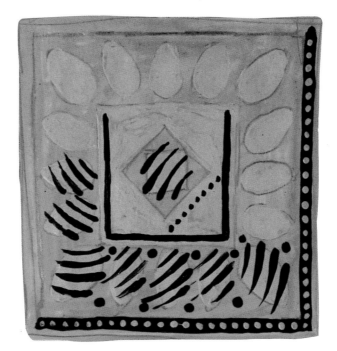

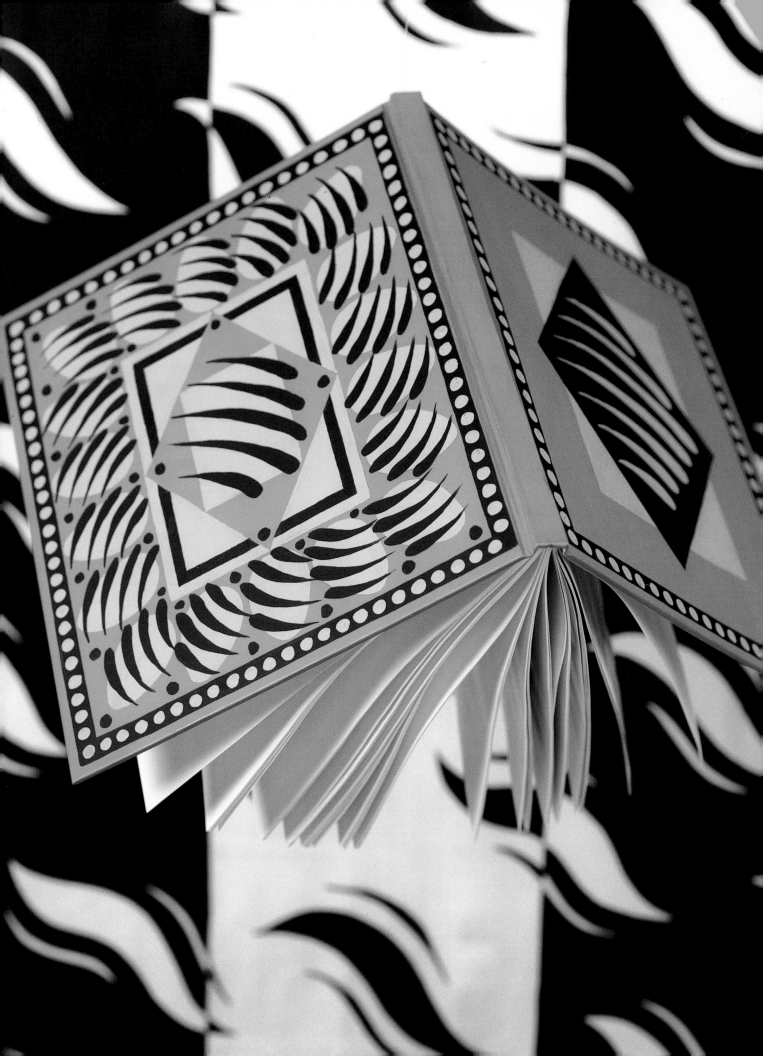

Apply two coats of orange paint to the cover of the book, taking care to paint around the edges neatly. When it is dry, you can draw out the design on the front. Draw lines at intervals of 5mm (³⁄₁₆in), 1cm (⅜in), and 5cm (2in) in from the edge. To draw the diamond, mark points bisecting each of the sides of the central rectangle, and join them up. To draw the rectangle inside it, do this once more. The egg-shaped template is used for the shapes around the outside of the rectangle. To help you position it, draw diagonal lines at each corner, and at right angles at the middle of each side. Use these lines as guides, tilting the shape gradually through 45 degrees between the middle and the corner. If your book is a different size and shape, you will have to work out the number of "eggs" per side.

Paint the central rectangles, the four triangles that make up the rectangle around the diamond, and the egg shapes all in yellow. Draw a 5mm (³⁄₁₆ in) border

inside the bigger yellow rectangle and paint it black, so the orange diamond appears to be in front of it. Also paint the outer border black. When it has dried, paint a row of yellow spots on top of it. Draw pencil lines over the yellow "eggs" and the central diamond, to create guidelines indicating the position and direction of the black dashes. Or cut out the stencil supplied and draw through this. Finish the front cover by painting the spots and dashes in black, and allow to dry.

On the back of the book, draw an outer border as for the front. Draw an inner rectangle 5cm (2in) inside it and create a diamond as before, but enlarge it by 1cm (⅜ in) all around. Paint the four triangles that make up the rectangle yellow, and the border and the diamond black. Paint the yellow spots again and add large dashes of yellow to the black diamond, marking them in pencil first as before. Erase any pencil marks showing, and varnish.

1. Drawing around the template. First rule out all the borders and then fit the "egg" templates into them. The one supplied fits a 5cm (2in) border and should work on most books. Find out by trial and error how many will fit the border.

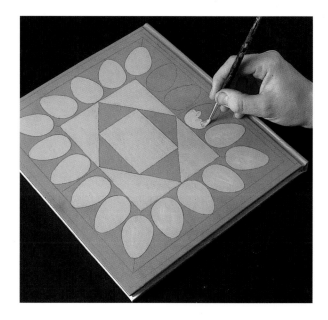

2. Painting the yellow areas. If you find painting the sharp corners hard, then use masking tape to help you. Paint the egg shapes last, creating the outlines first and then filling in the centers. The black lines on top will hide any wobbly edges.

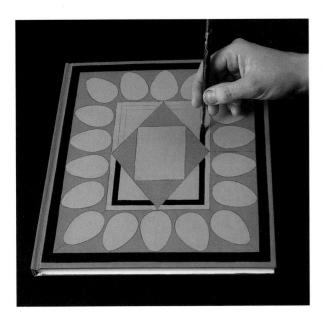

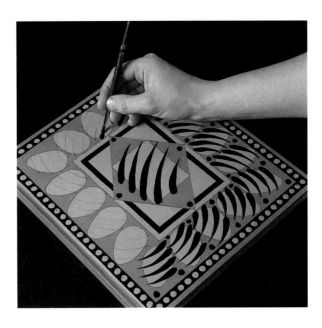

3. *Painting the black line as if it goes behind the orange diamond suddenly shifts the emphasis so that the background orange becomes foreground and the diamond sits on top of the rectangle. Paint the inner border first to prevent any smudging.*

4. *Before painting in the dashes, draw the guidelines for them, either by eye or by using the stencil. On a piece of paper, practice the technique. Either press your brush down first and gradually lift it so the line tails off, or try it the opposite way around.*

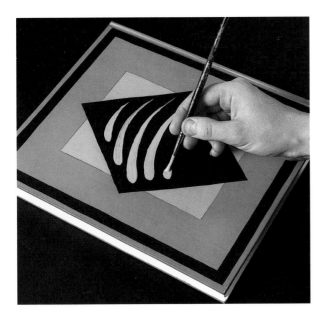

5. *Wait until the front of the book is completely dry before tackling the back. The design is a simpler version of the front with the colors reversed in the center. If you prefer, you could use this design on the front, or do both sides the same.*

6. *The yellow dashes are supposed to look spontaneous but in fact may not be. They are drawn in first and then painted carefully to form long "tadpole" shapes. A second coat of yellow may be necessary if the black is showing through.*

BOOK COVER

PLANT POT

MATERIALS

Large terracotta plant pot

*Flat latex paint:
yellow ocher, caramel,
dark blue*

*Low-gloss (matt) interior
varnish*

This splendid painted plant pot will add dramatic effect to any houseplant. The pot you choose to paint should be unglazed terracotta; try to avoid those with surface decoration, as this would interfere with the design and make it difficult to paint. The pattern I have used here is based on one of my textiles, which in turn was based on an old Chinese soldier's uniform with this very loose interpretation of a tiger skin. The arrangement of the design is quite simple and is left very much up to you, so you can use it on lots of differently shaped pots and need not search for one identical to this. You can transform an ordinary planter in a matter of hours and may be inspired to paint more of them, to suit different rooms in the house. Try other designs, such as those I have used on the lamp and the jug, or invent your own.

TOOLS

*Flat artist's brush,
2.5cm (1in) wide*

Pencil and eraser

Ruler or set square

Tape measure

3 templates

*Round artist's brushes,
medium and fine*

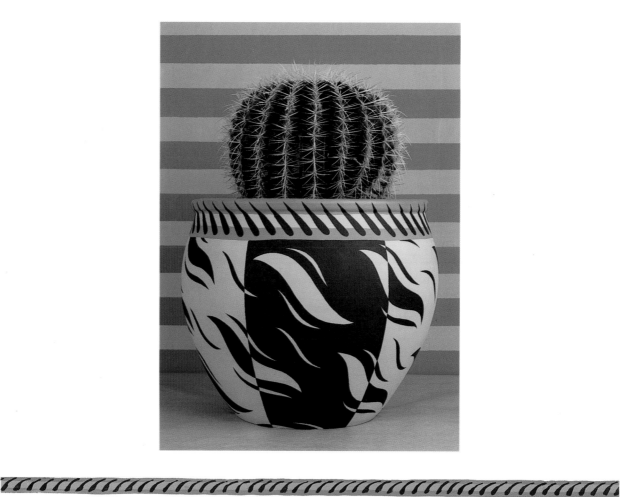

TIGER

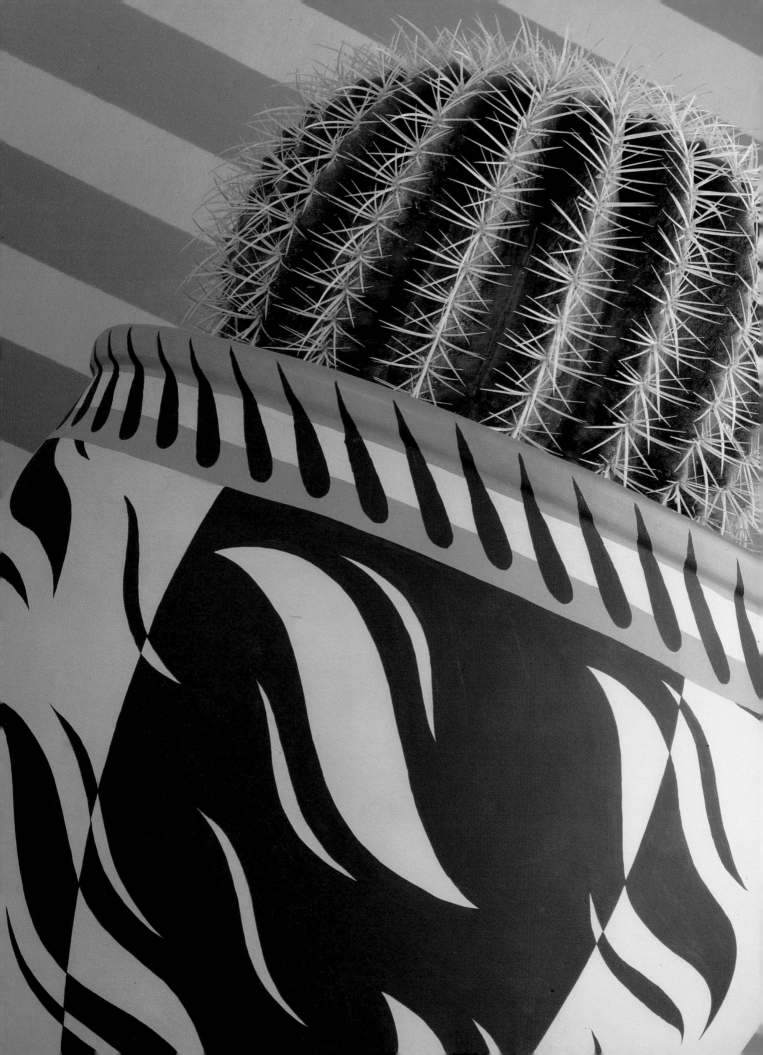

Paint the pot yellow ocher all over, finishing just inside the rim, as far as will show once your plant is in position inside the pot. Allow to dry. Next, draw in the lines for a 6.5cm (2½in) border around the top of the pot, with a band 2cm (¾in) wide running around the middle of the border. Turn the pot over, and measure the circumference of the base. Divide this by six and mark with a pencil. Draw a vertical line from one of these points, to meet the top border. Measure from this point around the pot, and mark off six equal spaces. Join the dots at the top and bottom to make five more vertical lines. You are now ready to start drawing out the main design. Use both variations of the main template, enlarged to about 20cm (8in) in length. Making sure to keep the guidelines vertical, draw these onto the pot, trying to space them fairly evenly all over. Using both the shapes adds interest and variety to the overall pattern. Any spaces that occur can be filled by drawing in one of the smaller lines. When you have finished the drawing to your satisfaction you can then start to paint.

Paint the caramel color on the two outer edges of the border, ending the upper one in a line at the middle of the rim. Then paint the main design using dark blue, first as a background and then as a foreground, reversing the colors at each stripe. Using the third template, draw on the striped part of the border, bending the template around the rim and placing one cut-out shape over the last one you drew to keep the spacing accurate. If the spacing does not work out properly when the pattern meets, you will have to erase some of it and respace it slightly, enlarging or reducing the gap between each stripe. Keep doing this until you are happy with the spacing. Finally, paint two dark-blue borders around the rim. Use the medium brush for the first, following the edge of the yellow, then use the fine brush to paint a fine line 3mm (⅛in) away. Allow to dry and apply varnish.

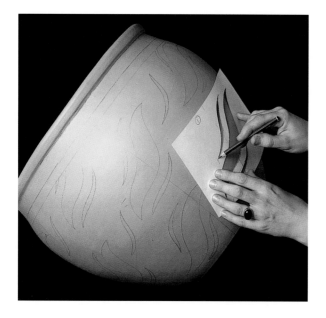

1. *Spacing the design on the pot may seem difficult but once you have taken the plunge and started you will soon gain confidence. The pattern disappears off the top and bottom of the pot and you can fill in any gaps with an extra stripe.*

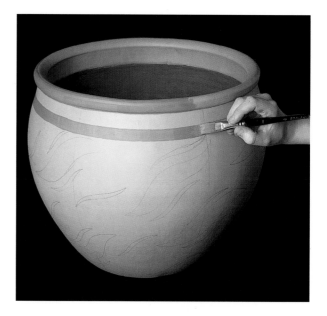

2. *Before painting these stripes you might like to draw yourself a line along the top edge, although the shape of the pot may provide a natural line. Turn the pot upside down when it is dry and neaten off the line that stops under the rim if necessary.*

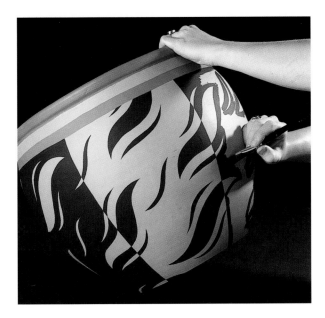

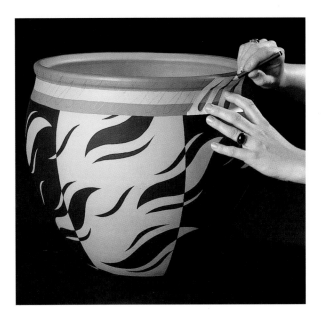

3. When painting the main design it is easiest to use a fine brush to paint the positive images and the edges and then go back and fill in the larger areas with a bigger brush. Tilt the pot or turn it over to find a comfortable painting position.

4. The striped border template provided is 6cm (2¼in) wide so that you can use the edge of it to keep you straight. You can stick it down with masking tape every time but you will still need to press it into the shape of the rim with your fingers.

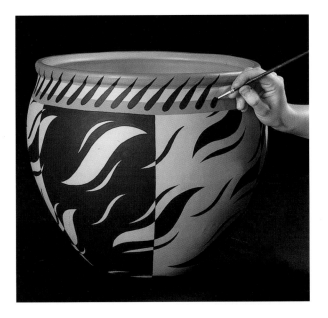

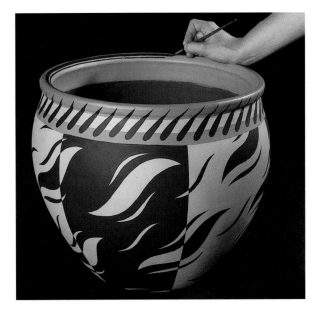

5. The border dashes have the appearance of being painted freehand, but would be very difficult to do that way because of the ridge of the rim. Instead, take your time and finish off the edges with a fine brush afterward to correct any mistakes.

6. The stripes around the rim are a deceptively simple finishing detail as they need a steady hand. Paint the wider one first and leave to dry before doing the narrow one. Keep the paint quite liquid and wash your brush frequently.

DECKCHAIR

MATERIALS

Deckchair with cream canvas

Primer

Flat latex paint: pale yellow, orange, black

Exterior-quality varnish

Masking tape

100ml (3½ fl oz) water-based fabric paint in black

Spray adhesive

The deckchair seems to be becoming a thing of the past, having been superseded by the director's chair. If you cannot find a suitable new deckchair, then this might be a good way of renovating an old one; the final result should be well worth the preparation required. When finished and reassembled, it would grace any garden or interior. If you do not have a chair with a cream seat, you will need to buy new canvas. When you remove the existing canvas, take note of how it was attached and use it as a pattern to cut and fit the new one, hemming it if necessary. The design used on the fabric is taken straight from one of the tiger rugs of Tibet which have long held a fascination for me. The pattern painted on the frame is one that I invented to go with my tiger scarves and has become a favorite border design of mine over the years.

TOOLS

Flat artist's brush, 2.5cm (1in) wide

Round artist's brushes, medium and fine

Round or flat hog-bristle artist's brush, medium

Pushpins

Large wooden board

Long ruler

Pencil

Set square (optional)

2 templates

Scissors

Soft-colored pencil or tailor's chalk

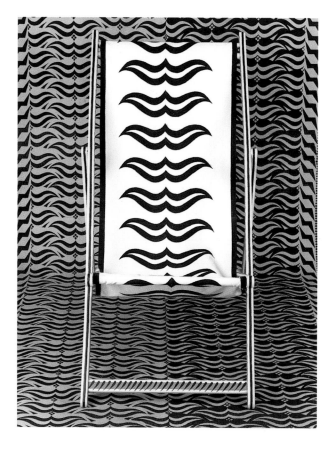

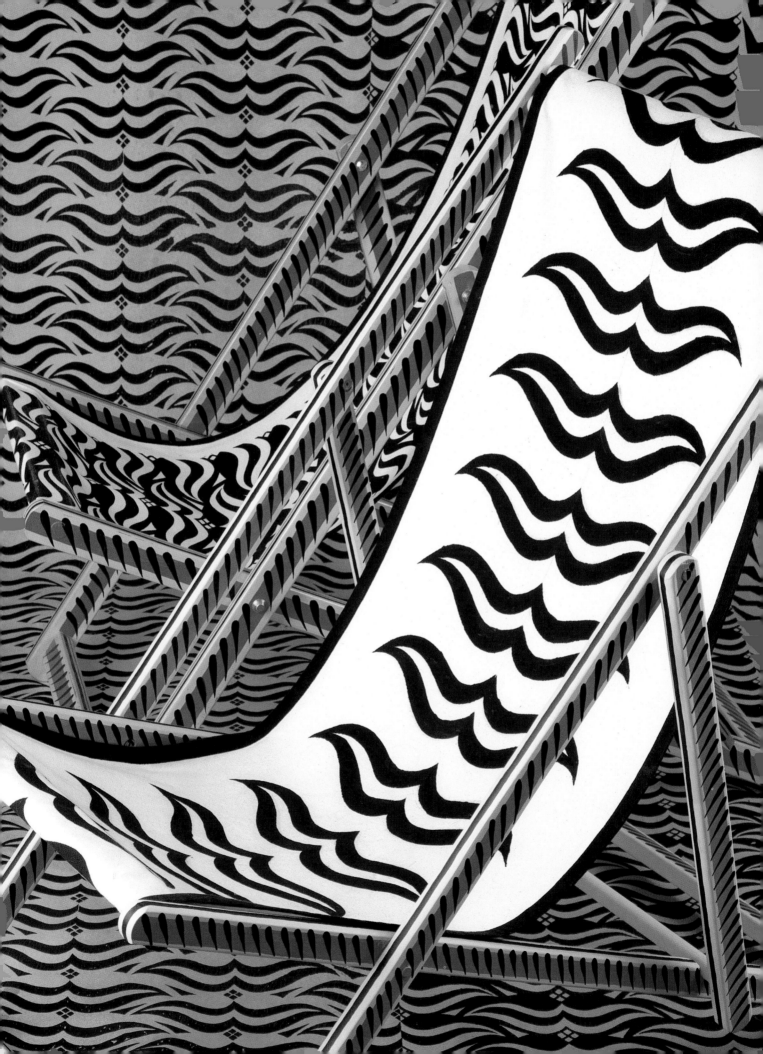

FRAME

Sand and prime the frame and paint with two coats of pale yellow. Using the flat artist's brush, paint bands of orange on the inside and outside faces of all the struts and crossbars. On the narrower faces (top and bottom), paint black lines, using the medium brush. Paint black diagonal "tiger" stripes over the orange, about 2cm (¾ in) apart. Start by using the point of a medium brush, then flatten it out to widen the stroke. Make sure all these strokes go in the same direction, with the wide end upward. Apply several coats of varnish.

CANVAS

Stick masking tape along both long edges on both sides of the canvas 1.5cm (⅝ in) in from the edge. Following the manufacturer's instructions, use the hog-bristle brush to apply fabric paint in a stripe down each side of each edge, outside the masking tape; check the outer edges for white gaps. Remove the tape when the paint is dry. Pin the canvas onto the board, stretching it tightly. Rule a faint line down the center of the canvas. Enlarge the template to a width of 16cm (6¼ in) and cut out the shaded areas to use it as a stencil. Trace the guidelines onto the back of one so that it can be used in reverse, and keep in reserve.

Following the manufacturer's instructions, apply spray adhesive to the back of the first stencil and stick it onto the canvas at one end, using the central line to position it. Paint through the stencil carefully using fabric paint and the hog-bristle brush. Work down one side of the fabric, repeating the pattern. Use the cut-out shape at the top of the stencil as a guide, lining it up with the motif just stenciled. If paint seeps under the stencil, use the fine brush to smooth out the line.

Repeat the process using the reverse stencil down the other side of the fabric. When it is dry, turn it over. Some black will show through but will be covered by the design on the back. Cut new stencils and draw another central line before starting. Stick the first stencil down in the same position as the one on the other side. When finished, fix the paint following the manufacturer's instructions and reassemble the chair.

1. *Paint the orange bands on all the outside- and inside-facing struts. If the crossbars also have flat edges and are not rounded, paint these as well. Keep changing the position of the chair so that gaps in the paint show up now, not later.*

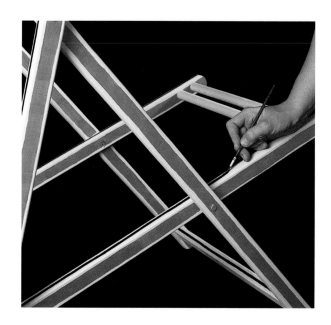

2. *Paint thinner black lines on the upward- and downward-facing edges. Most of these can be done with the deckchair in the folded position, which you might find easier. Take care not to scratch off the paint while maneuvring the chair.*

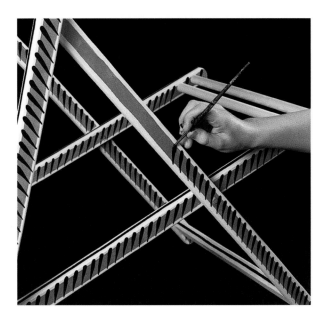

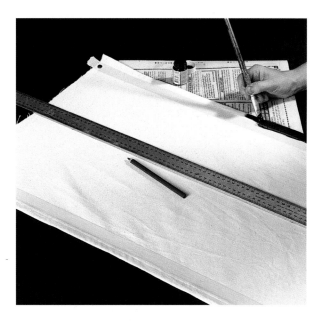

3. *The black tiger stripes should be painted at approximately 45 degrees; draw a few guidelines with a set square if you like. I find that the painting method already described works well for such short strokes, but use whichever method suits you best.*

4. *Paint both edges of the canvas, all around the hem (if there is one) to the other side. When dry, remove the masking tape. Find the center of the canvas and draw a faint line down the middle. Rub it off with a soft cloth when the paint is dry.*

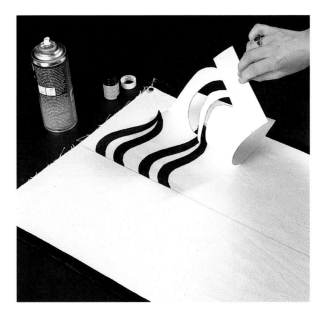

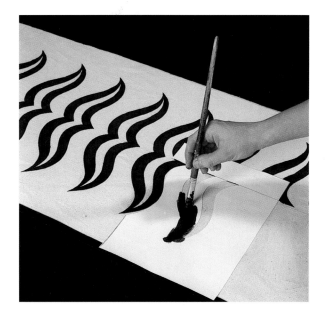

5. *Apply the fabric paint through the stencil carefully, using a hog-bristle brush and working from the edges inward. Take care not to bend back the fragile central strip. When removing the stencil, pull up from the "backbone" side first.*

6. *The final stage: the stencil is positioned fitting exactly under the image above it and lined up on the central pencil mark. Check that a tiny bit of black shows where the two parts of the pattern meet so you know they will match.*

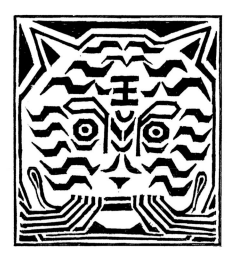

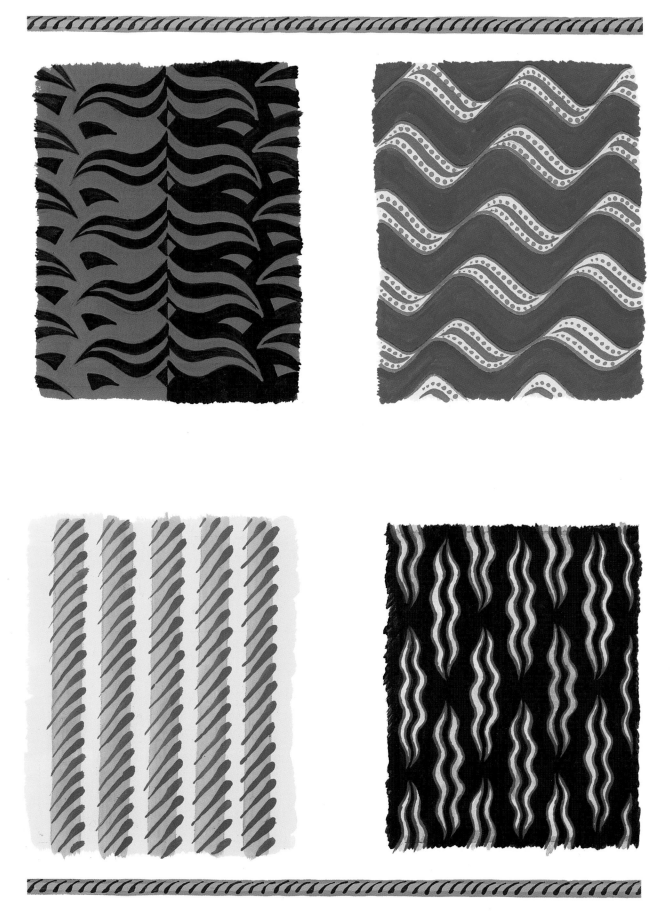

VARIATIONS
109

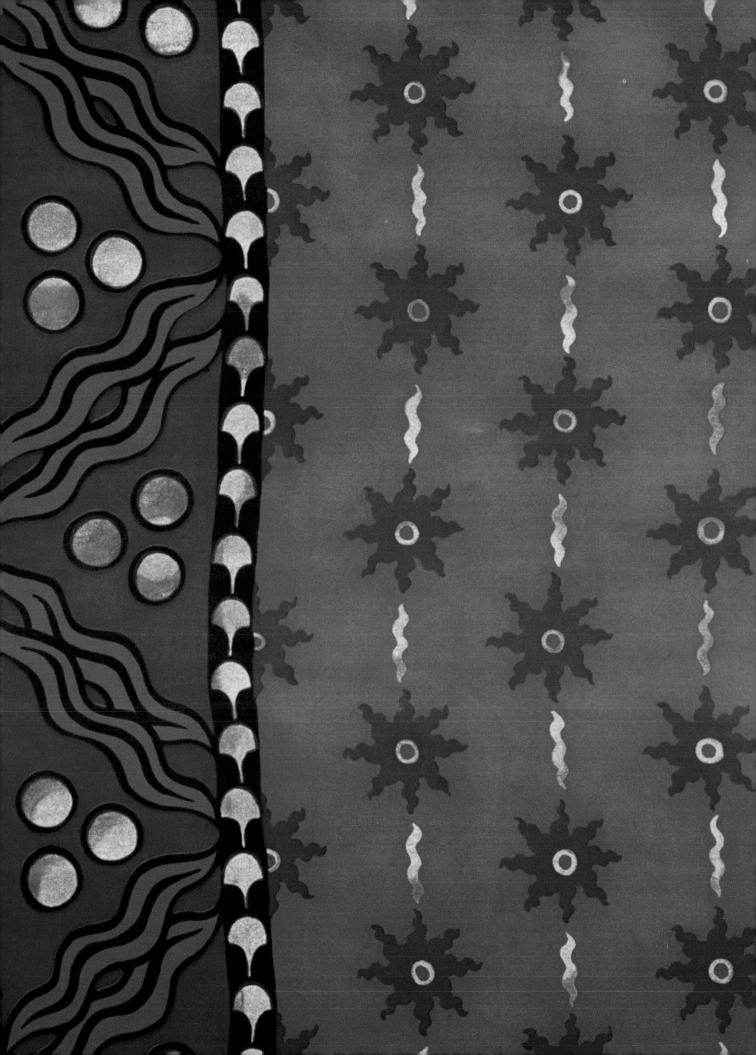

MISCELLANY

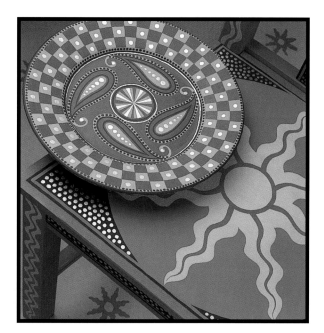

This is a section of randomly selected patterns, with no obvious
theme to link them. Some of them are commonplace images
for which I felt it would be useful to have a template, such as a sun,
a fleur-de-lys, or a carnation. Others are designs which incorporate
one or more of the previous themes to show that there are ways
of rearranging these shapes to make them look new and different.
Either way, I hope this section will be useful as a starting point to
enlarge your design vocabulary so you can create many
original designs of your own.

PLATES

MATERIALS

Unglazed plate(s)

*Flat latex paint: violet,
scarlet, dark blue*

Gold paint

*Low-gloss or high-gloss
interior varnish*

I am an avid collector of plates, having started with a couple of fine Delft plates which belonged to my grandmother and having gone on to acquire more from many other parts of the world. It has never really mattered to me whether these plates are usable or not; those which can be are often pressed into service but the more fragile ones remain on the wall or the dresser. Surprisingly, it had to be suggested to me that I could paint my own, using latex paint. I have always been put off by the assumption that I must use proper glazes and a kiln, probably because my father is a potter and I have made many paltry attempts at pottery in the past. The fact that these plates are purely decorative is immaterial if they would not have been used anyway. Although this project shows you the stages of painting only one plate, you can use the other templates to paint yourself a whole dresserful using the same basic techniques.

TOOLS

*Flat artist's brush,
2.5cm (1in) wide*

Template

Scissors

Pencil and eraser

*Round artist's brushes,
medium and fine*

Ruler or set square

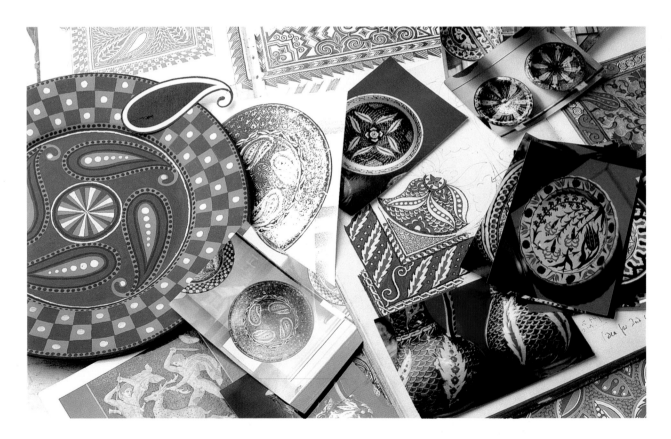

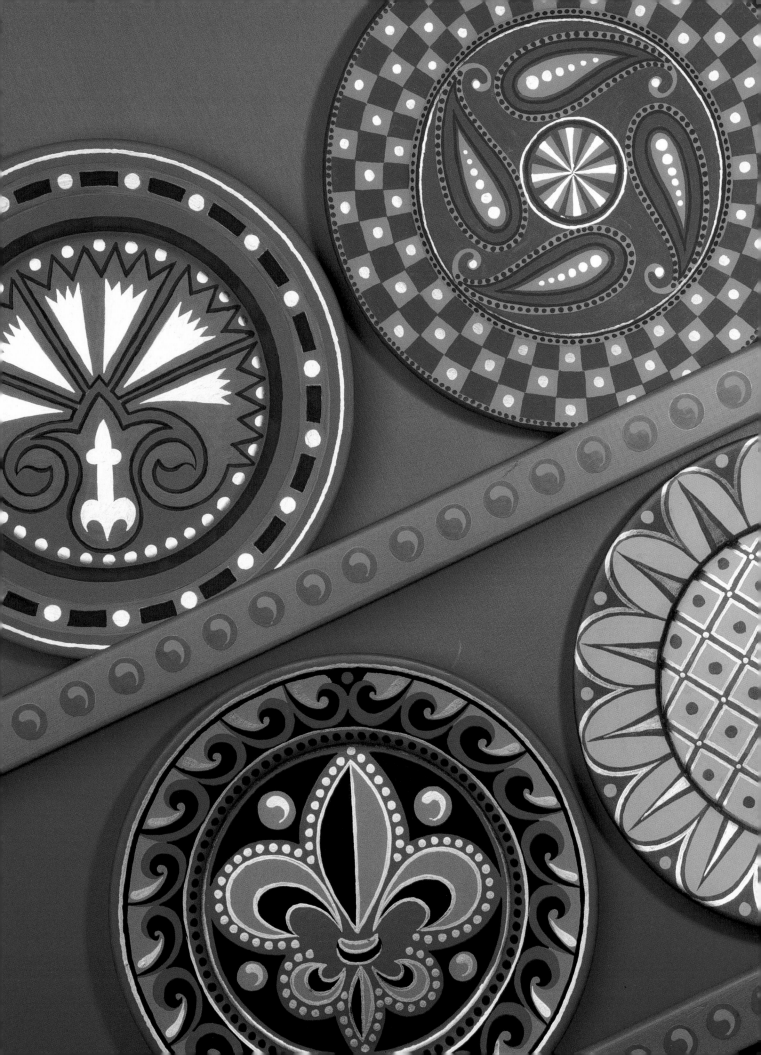

Paint the whole plate, back and front, with violet emulsion. Enlarge the carnation template to fit the center of the plate. Cut around it, leaving the area between bud and petals to hold the template together. Place it in the middle of the plate and draw around it. Make a border by drawing two lines around the rim of the plate at intervals of 1.5cm (⅝in). Paint this border and the carnation in scarlet, using two coats if it does not cover well the first time. Draw in another border about 1cm (⅜in) wide, starting at the ridge where the rim of the plate meets the center. In the scarlet band, draw little rectangles punctuated by spots, as shown. They are about 2cm (¾in) apart, but if after working around the plate you find that they do not fit, erase a few and enlarge or reduce them slightly. Trial and error usually works better than math. Use the dark blue and the fine brush to paint these and the inner border and a fine outline all around the carnation.

Next, use the template again, cutting out the petal patterns and drawing through them onto the carnation in pencil, and paint these patterns in gold.

Paint gold spots in a circle around the plate, between each zigzag of the petals, and add some more around the scarlet border. A very fine gold band goes around the edge of the plate. Draw a pencil line first if you need a guideline, or paint the line freehand if you feel confident enough to do so. When the plate is dry, give it a coat of varnish, which can be either low-gloss (matt) or high-gloss, depending on whether you want to maintain the illusion that the plate has been glazed.

The other plates are painted in a similar way, using the templates provided. Start with a background color, draw in the design, and work in stages of different colors to build up the design gradually. The gold paint adds a final embellishment but it could be replaced by another color if you prefer.

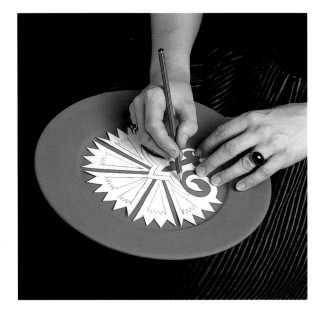

1. Place the template on the plate, leaving an even amount of space all around. When you have drawn around the carnation, remove it and draw in the lines separating the petals from the bud; these cannot be cut out or the template would fall apart.

2. Paint the scarlet carnation and border using two coats of paint if it does not cover well. Leave violet gaps between the separate parts of the flower, as it is intended to be a very stylized shape based on a traditional Turkish textile design.

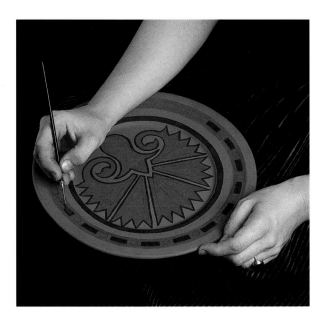

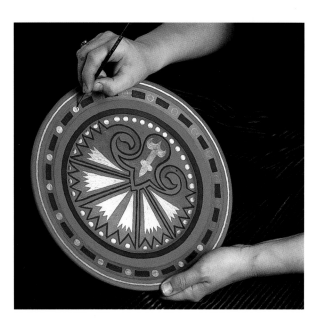

3. *Use your finest pointed brush to paint a dark-blue border all around the carnation. When spacing the little blue rectangles around the scarlet border, trial and error may be the only solution, even if some end up a slightly different size.*

4. *The patterns on the carnation are drawn in using the template for a second time, on top of the scarlet, and are painted gold. More detail is then added, working from the inside outward to avoid smudging.*

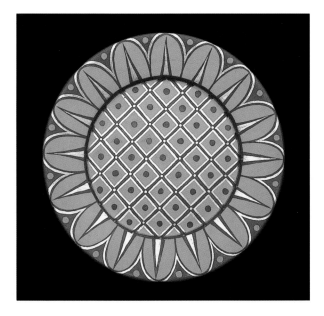

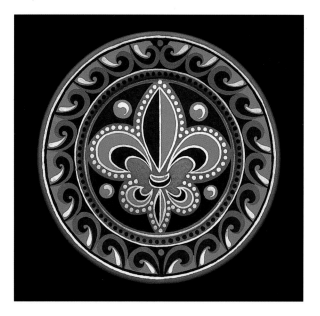

5. *This yellow and green sunflower plate is painted yellow all over first. Next, the center is drawn out in checks and painted in, and finally sixteen petals are added around the edge using the points of the compass to divide the edge evenly.*

6. *This plate was painted blue-gray, then the fleur-de-lys template was used to draw the central pattern. The curly pattern was fitted in by eye. Green and black are used for the main areas and the whole pattern is highlighted in gold.*

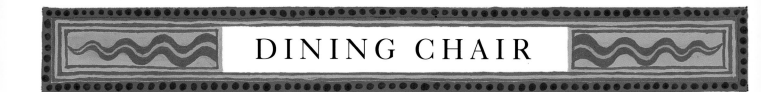

DINING CHAIR

MATERIALS

Wooden dining chair

Primer

*Flat latex paint:
deep yellow, bright blue,
crimson, dark blue*

Gold paint

*Low-gloss (matt) interior
varnish*

For this project you need a wooden chair with a smooth, flat seat. The one used here is a modern, inexpensive one, but a second-hand one would do just as well, although the design might need adapting slightly to fit the particular chair you have chosen. The idea is to make something very bright and lively to cheer up a room and it is especially satisfying to have as your starting point something as commonplace as a plain wooden chair. The design is a sun shape based on a Turkish fabric design, and is used both for the back and for the seat, where it has been enlarged. The legs echo the wavy sun with an appearance of flames licking upward, and gold spots add to the celestial theme. It might be fun to paint another chair in a complementary moon design, with the two blues reversed, or to make a whole set like this.

TOOLS

*Decorator's brush,
2.5cm (1in) wide*

Ruler or set square

Pencil

3 templates

Scissors

*Flat artist's brush,
2.5cm (1in) wide*

Round artist's brush, fine

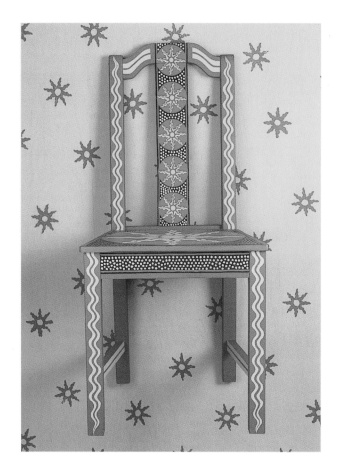

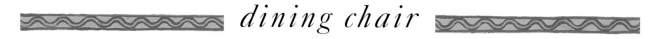
Prepare and prime the chair and paint it all over with yellow latex paint. Use your set square or ruler to draw borders 1cm (⅜in) wide all around the seat, the batons supporting it, and the top of the back-rest. The templates are used to draw the rest of the design onto the chair. Enlarge the sun to make two templates of the right sizes to fit the back-rest and the seat, but do not cut them out until you have drawn the surrounding circles. The large one should fit on the seat with its edges barely touching the borders and the ones on the back should just fit the width. Draw the circles on the back-rest, spacing them evenly, starting with the ones at the top and bottom and positioning the rest by eye in between them. Cut out the sun shapes and draw them in position. In the same way, draw the circle and then the sun shape onto the seat of the chair. Use the wavy template to draw the patterns onto the outside faces of the legs. The template pattern is repeated, fitting into itself, until near the top and the bottom, when you use the tapering wavy template to finish it

off. Trial and error will get it to end at the right point.

Use the bright-blue paint to fill in the backgrounds to all the suns within the circles. Next, paint in all the crimson edges; these go not only around the wavy lines, but also on the insides of the legs and on the borders around the seat, beneath it, and on the top of the back. Paint the supporting bars of the chair with red stripes, as shown in the main picture. Anywhere there is to be no pattern is painted crimson. Now paint dark blue around all the circles and inside the borders under the seat. The crimson lines across the top of the back and up and down the legs are next. These go down the middle of the wavy lines, following the same shape and tapering toward the top and bottom. They also follow the line of the central circle in the suns and taper outward to the end of each ray. (Draw these lines in pencil first if you prefer.) Bright-blue lines are then drawn around all the dark-blue areas before they are filled in with gold spots. When everything is dry, apply at least two coats of varnish before use.

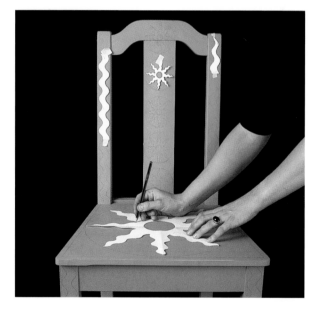

1. After drawing in the circles surrounding the suns, cut out the sun shapes, including the central hole, and draw around them, positioning them inside each circle. Make sure that the rays of each sun point in the same direction.

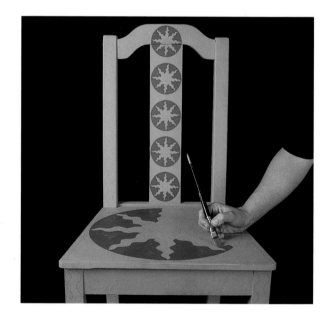

2. Paint in the blue backgrounds to the suns, using a fine pointed brush for the little ones. The small suns should also be painted down the other side of the back-rest, as this side is likely to be more visible.

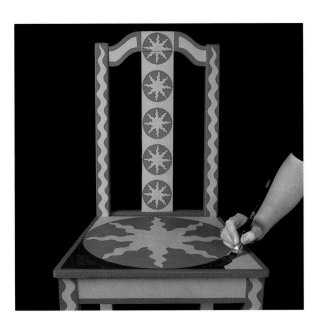

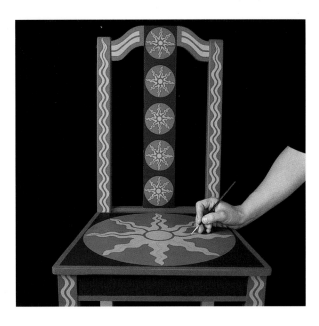

3. *The dark blue is painted around all the blue circles. On the back-rest, paint this blue to the edge, but paint red on the inside edge, and on all the insides and undersides of the other parts of the chair, as well as the visible parts.*

4. *The wavy red lines should follow the existing lines on the legs. To paint the rays of the suns use a fine brush, starting with it flattened to form a wide line. Gradually lift it and let the line taper out toward the end of the ray.*

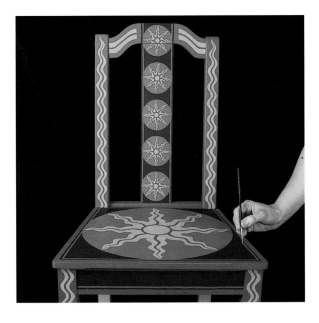

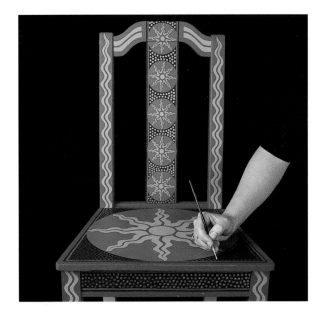

5. *The bright-blue lines are painted about 5mm (³⁄₁₆ in) in from the edges of all the areas already painted dark blue. Where they collide with the circles they are allowed to merge in with the background blue and then emerge again on the other side.*

6. *To paint the gold spots, start by working around the edge of the area to be filled. Then go back and try to cover the central portion so the spots are as evenly spaced as possible (though this is not crucial – as you see, mine are quite uneven in parts).*

CHEST OF DRAWERS

MATERIALS

Wooden chest of drawers

Primer

*Flat latex paint:
pale yellow, turquoise,
royal blue, orange,
dark purple*

*Small piece of stiff
cardboard*

*Masking tape,
1.25cm (½in) wide*

*Law-gloss (matt) interior
varnish*

Painting a chest of drawers is not as difficult as it might seem at first glance. The surfaces to be painted are all flat, the drawers can be taken out so they are easy to get at, and the handles can be removed. A really pretty chest of drawers can be expensive, so the idea of decorating one of the many dull ones to be found is quite attractive. The one used here is modern, but a second-hand piece would do very well, especially as any damage can be repaired or filled first, leaving the paint to hide a multitude of sins. This sort of thing would be ideal for a child's bedroom, or maybe a hallway or kitchen where the colors could be changed to suit a particular color scheme. The design is a composite of stripes, spots, and leaf shapes and incorporates a decorating technique known as "sgraffito", where the wet paint is scraped off to reveal a different color underneath.

TOOLS

*Decorator's brush,
2.5cm (1in) wide*

Pencil and eraser

Ruler or set square

3 templates

*Flat artist's brush,
2.5cm (1in) wide*

Sharp craft knife

Round artist's brush, fine

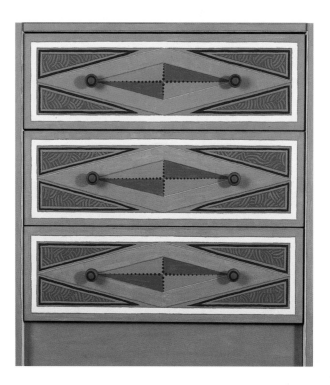

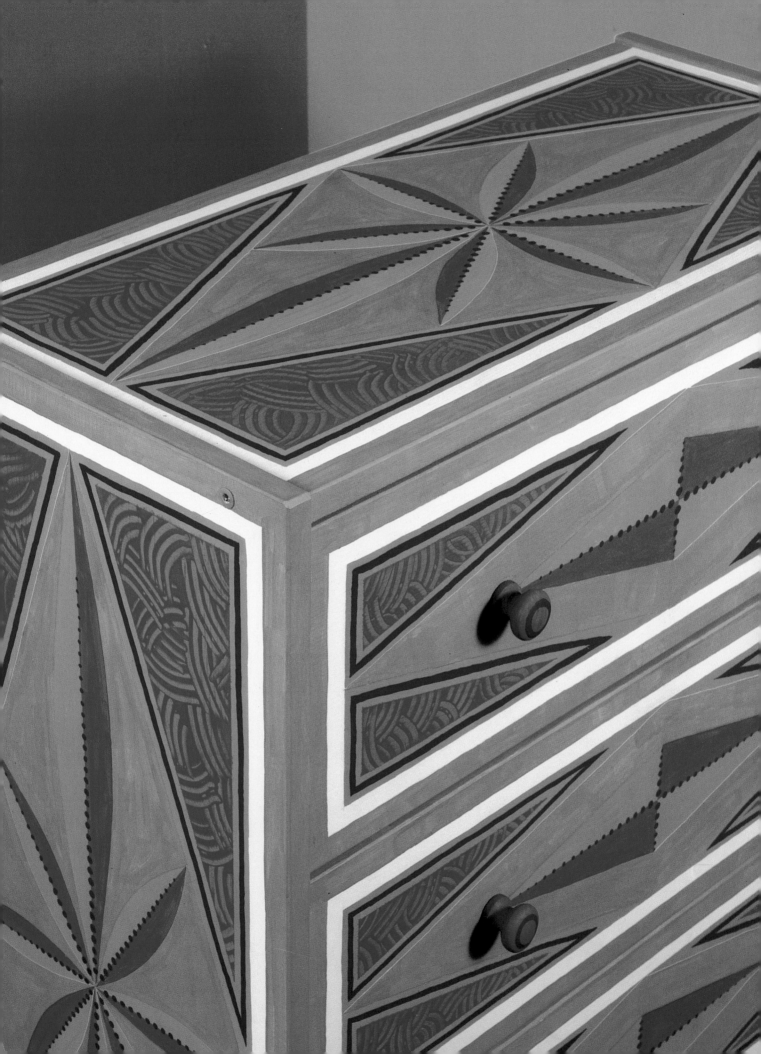

Prepare and prime the chest of drawers and paint with the pale-yellow base color, either stopping at the edges of the drawers or painting the whole of the interior. If you like, the interior could be painted in a different, contrasting color. Next, draw out the design on both sides and the top. Draw a border 1.5cm (⅝in) around the outside, and another 1cm (⅜in) wide inside it. Inside the inner lines, draw a diamond by joining the center points of each side. Make a cross at the center of the diamond, and then mark another one to form an eight-pointed star. Judge the position of these lines by eye so that the diamond is evenly divided and symmetrical. Enlarge the leaf-shaped templates to fit each ray of the star and draw them in place, using the central line to position them. Paint the areas of flat color within the diamond as shown, using the turquoise, royal blue, and orange.

Before starting to paint the textured areas you will need to make yourself a cardboard "comb." Cut this out from the stiff cardboard with a sharp knife, making four prongs, each 5mm (³⁄₁₆in) in width and 3mm (⅛in) apart. Mask out the edges of the turquoise triangles with the masking tape, then paint all over this area with royal-blue emulsion. Before this dries, comb it off again in a random pattern so that the resulting stripes go in different directions. Repeat this procedure with each of the areas to be covered. Remove the masking tape and paint a fine dark-purple line around each area of sgraffito. Finish off with a line of purple spots down the spine of each "leaf," starting large in the center and gradually diminishing to a dot at the outer edge.

The front of each drawer is painted in the same way; the only difference is that the star of leaves is replaced by a further diamond, with its points ending where the handles screw in. This diamond is divided into quarters, painted in the two blues, and then embellished with spots, like the leaves. Paint the handles to match (if they are wooden) then apply a couple of coats of low-gloss (matt) varnish to finish.

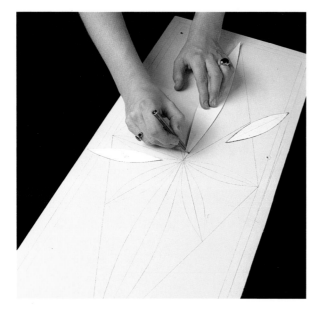

1. *Use the template in different sizes to draw the pattern onto each side of the chest of drawers. The position of the diagonal lines is determined by eye, like slices of a cake, and should not be at exactly 45 degrees unless the side of the chest is square.*

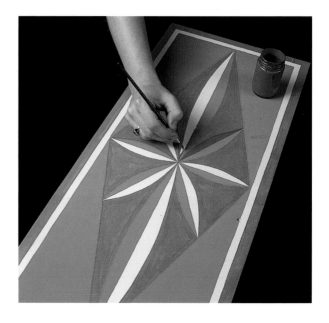

2. *The areas of color are painted using a small brush to paint the edges and a larger one to fill in the spaces. For a flat finish with no brushmarks, you may need a second coat, especially with the orange, as oranges and reds seldom cover smoothly.*

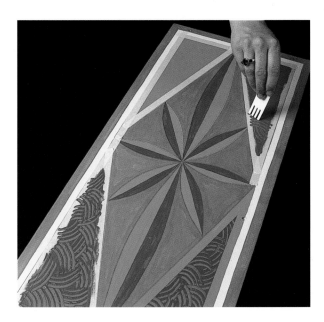

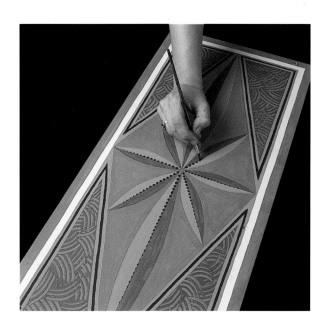

3. *Mask out a border 1.25cm (½in) wide with tape before painting royal blue over the top. Scrape through this to reveal the turquoise beneath; use a slightly circular motion and change direction at every pull to achieve an overlapping pattern.*

4. *Paint a dark-purple line in the triangular borders left by the tape. Paint spots along the leaf shapes, starting with ones about 6mm (¼in) wide at the center. Gradually decrease their size and increase the distance between them until they peter out.*

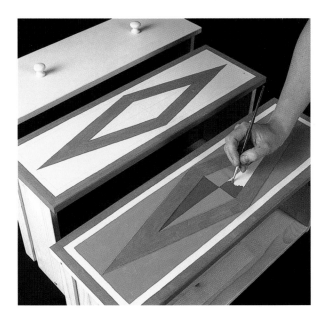

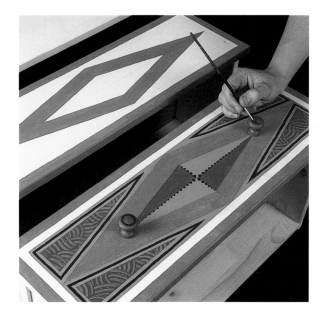

5. *Take the drawers out of the chest and remove the handles before painting. Make a diamond shape as before, then draw another one inside it, with edges parallel and each apex at the points where the knobs screw in. Paint in the flat areas.*

6. *If the drawers have wooden knobs you can paint them to match, with the decoration of a little line or some spots. Before reassembling, use orange latex to paint the front and bottom edges of the chest and the edges of the drawers.*

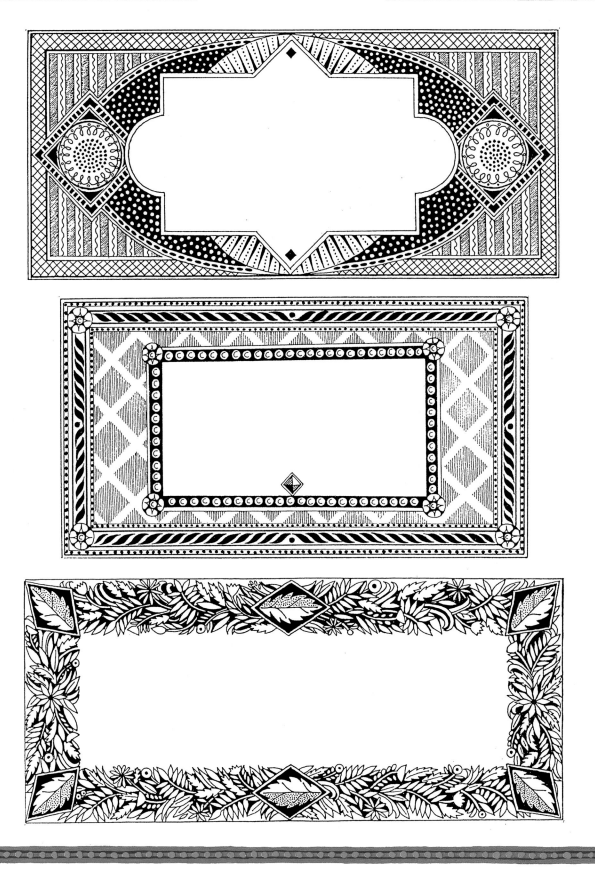

ACKNOWLEDGEMENTS

The author would like to thank Jenna Jarman, Meryl Lloyd, and Nadia Mackenzie for all their hard work and for making this book such fun to work on.

The author would also like to thank:
Paul Beecham
Quentin and Olivier Bell
Francoise Benattar at Charles Barker plc
The Charleston Trust
Tony Clarke at Decorate and Fire
Christopher Farr and Matthew Bourne at Christopher Farr
Shirine and Tony Hammond
Christine Miles
Bill and Virginia Nicholson
Adrian Reith at Zoo Studios

SUPPLIERS

All painted furniture, objects, fabrics, designs, and decoration in this book are the work of Cressida Bell and are either available or can be produced to order from:
Cressida Bell
1a Princeton Street, London WC1R 4AX, UK
Tel:011-44-171 404 3191 or 011-44-181 985 5863
Opening hours: 10am–6pm, Tuesday to Friday

FURTHER READING

Isabelle Anscombe, *Omega & After: Bloomsbury & the Decorative Arts*, Thames & Hudson, 1981

David Black, *World Rugs and Carpets*, Country Life Books, 1985

Josette Bredif, *Toiles de Jouy. Classic Printed Textiles from France 1760-1843*, Thames and Hudson, 1989

Jocasta Innes, *Paintability*, Weidenfeld & Nicholson, 1986

Mimi Lipton, *The Tiger Rugs of Tibet*, Hayward Gallery, London, 1988

Susan Mellor and Joost Elffers, *Textile Designs. 200 Years of Patterns for Printed Fabrics arranged by Motif, Colour, Period and Design*, Thames and Hudson, 1991

Gilliane Naylor (Ed.), *William Morris by Himself. Designs and Writings*, Macdonald Orbis, 1988

Charles Spencer, *Leon Bakst*, Academy Editions, 1973

Max Tilke, *Costume Patterns and Designs*, A. Zwemmer Ltd., 1956

The Victoria & Albert Colour Books Series, Webb and Bower in association with Michael Joseph Ltd. in association with the Victoria & Albert Museum, London.

PICTURE CREDITS

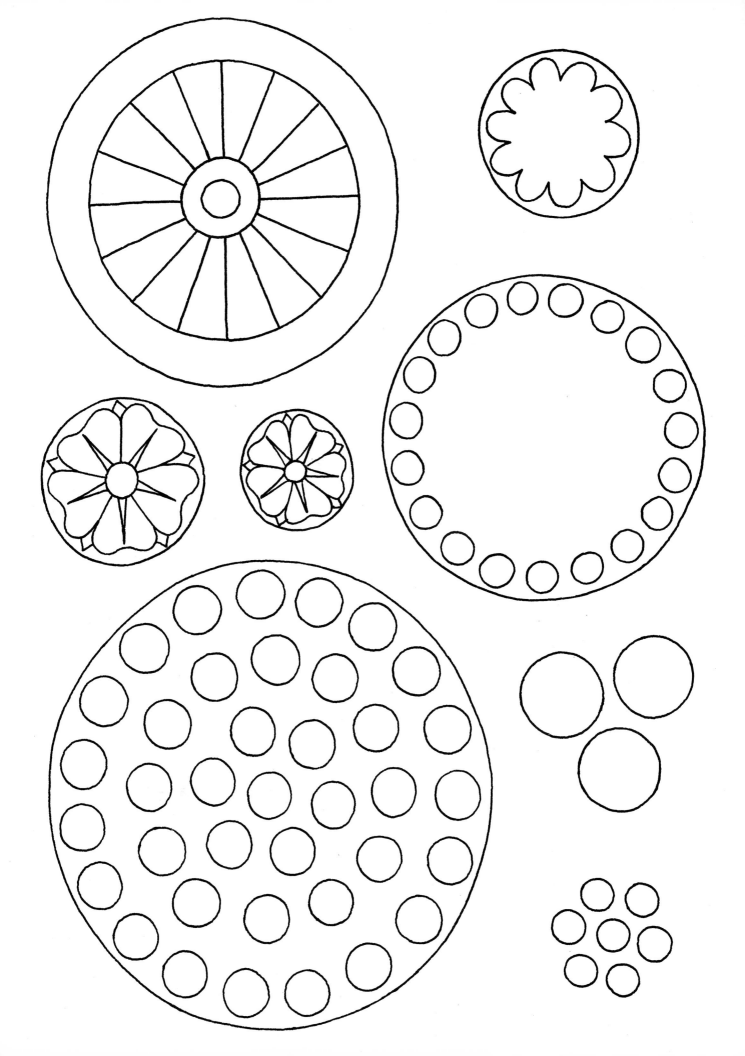

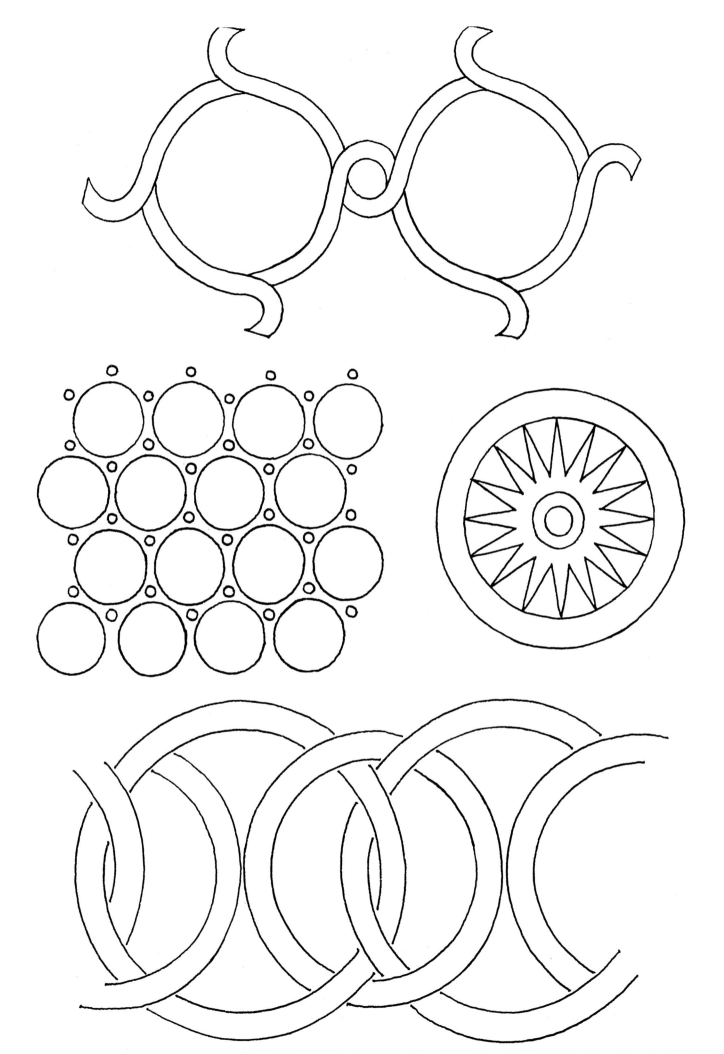

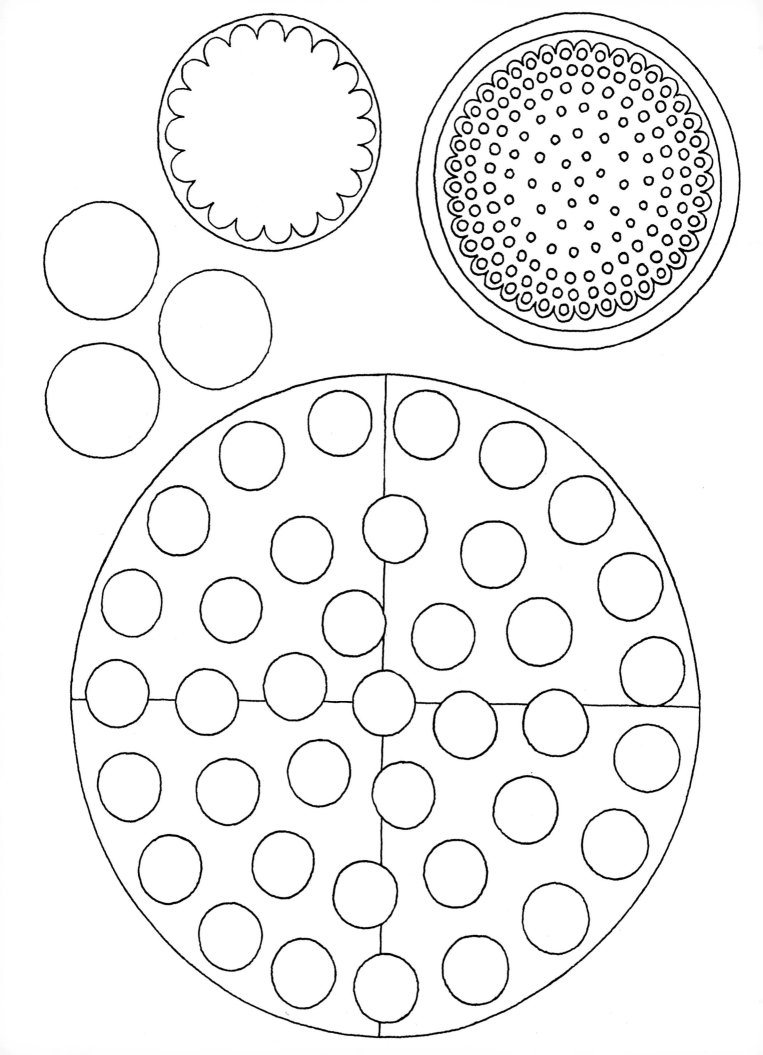

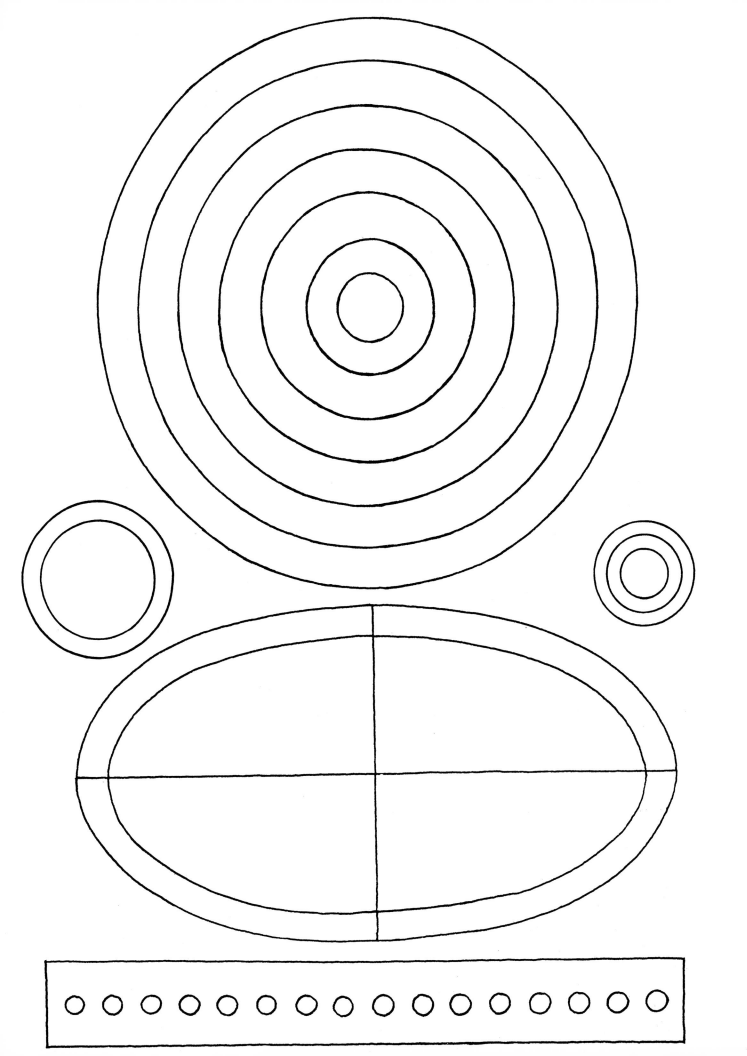

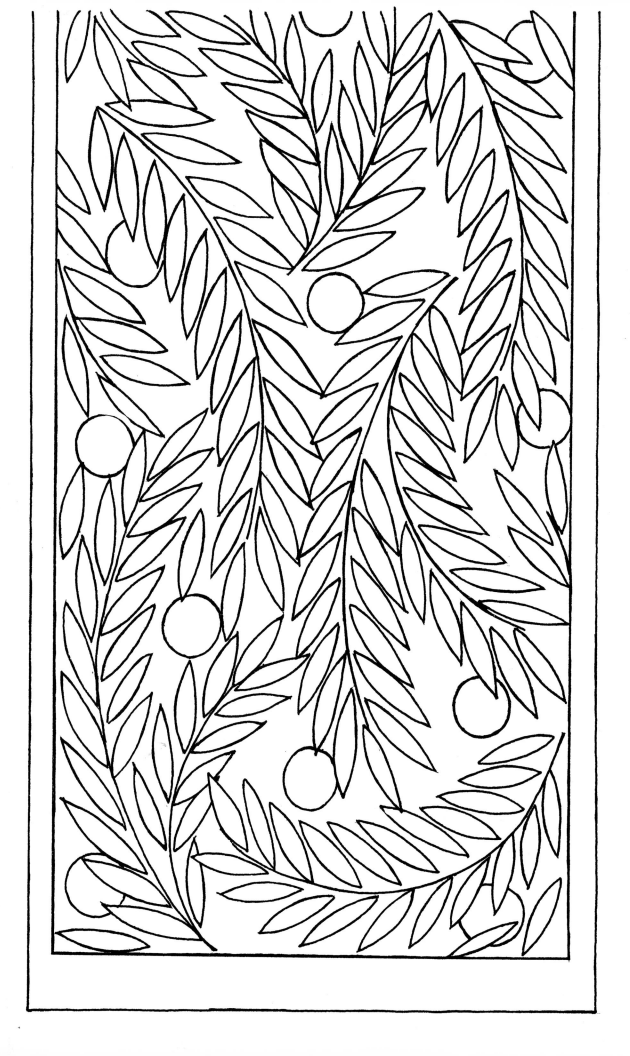

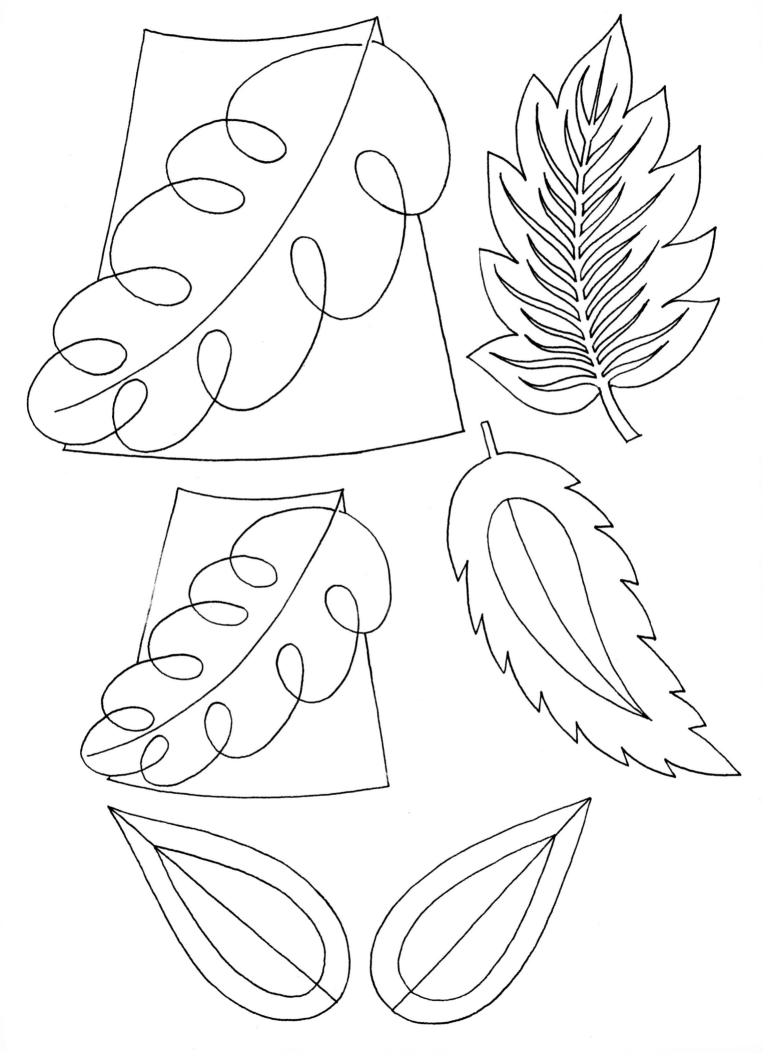

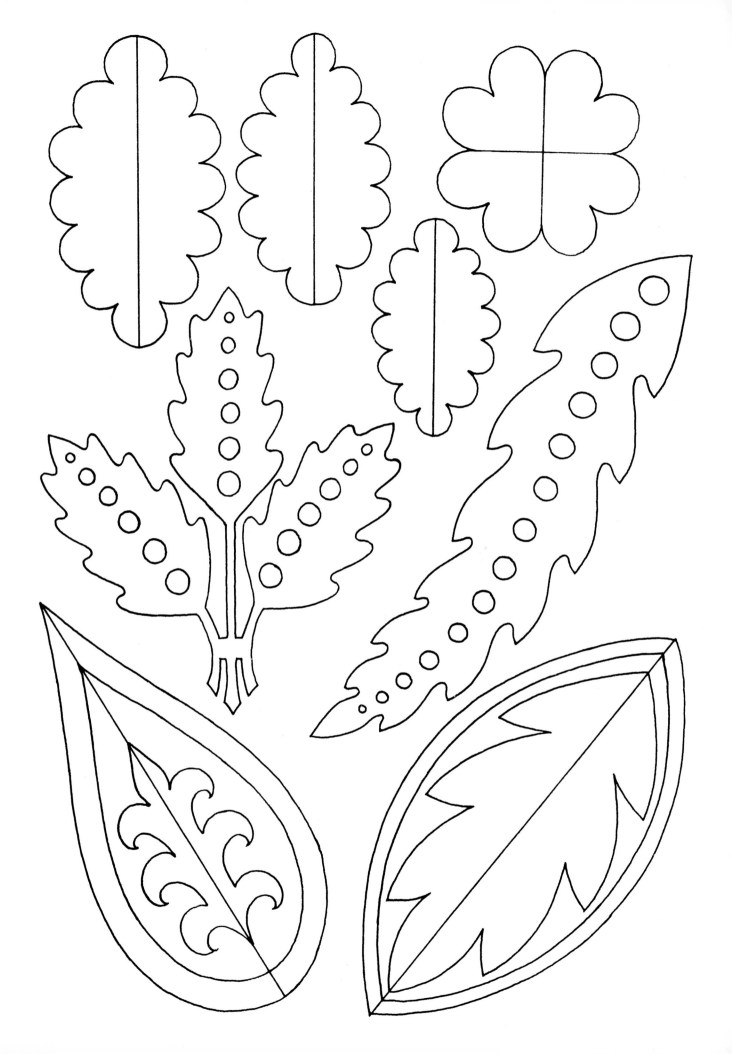

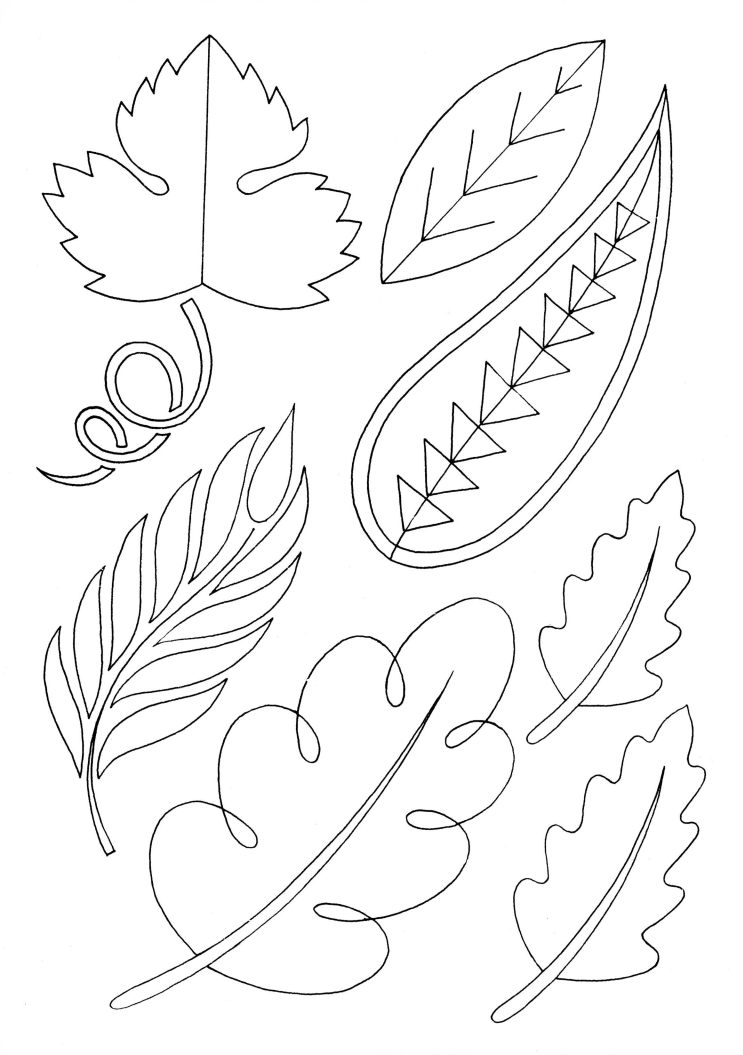

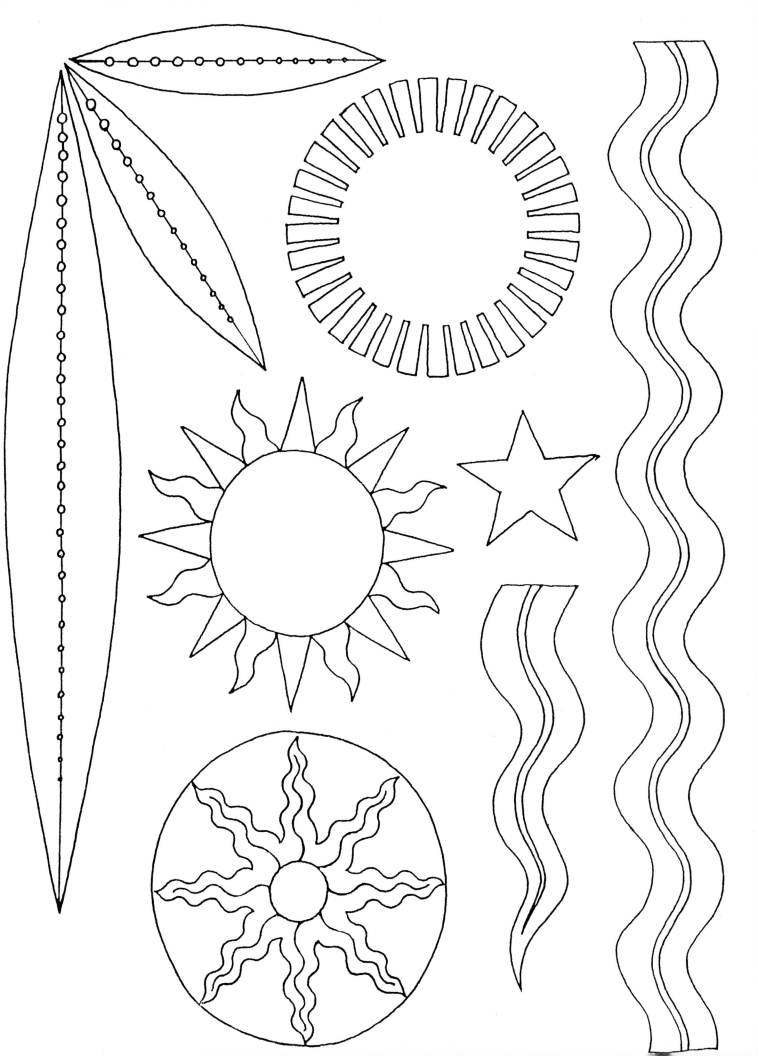

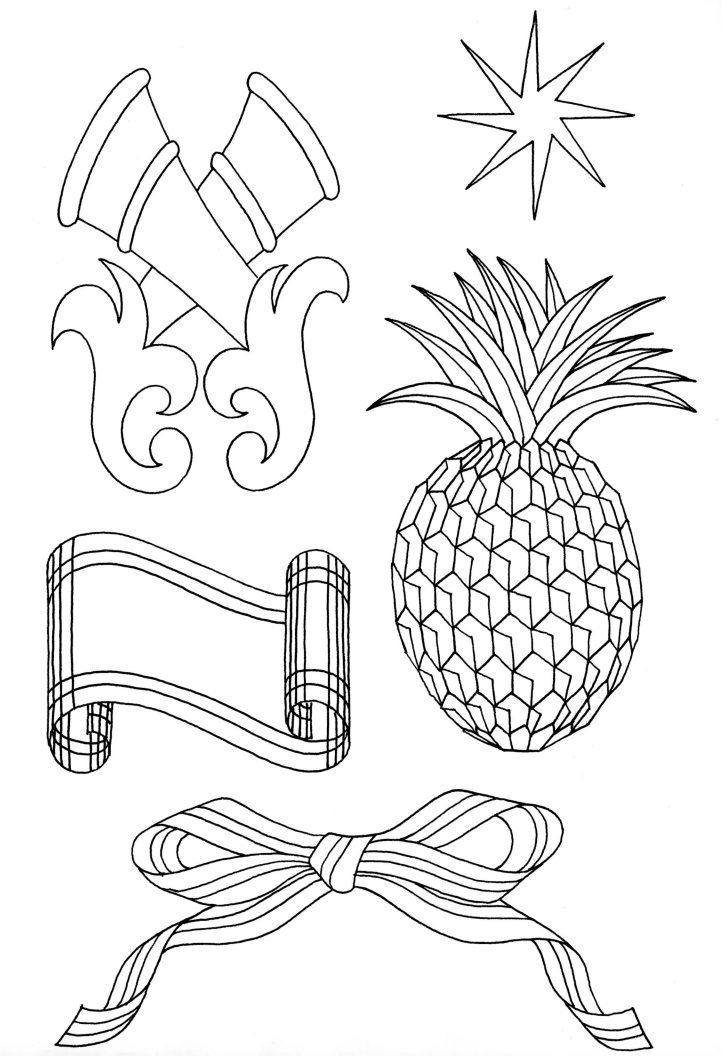